APERTURE

Here, in a reverie of skin, sand, and sun, for the first time in photography, are newly discovered and forgotten masterpieces of sensation by seventy photographers from around the world.

It is especially fitting that swimming serves as the focus for this international event. Ever new, the body's plunge into water invites a range of emotions experienced by people everywhere—from unadulterated joy to sheer terror. It is the brush with the unknown, the conquered fear, the new territory, the weightlessness of being, harkening to the song of sirens rather than the dictates of reason.

In these superb photographs—optical vortices of surface, sunlight, refraction, and shadow—water becomes sky, man becomes fish, form merges with formlessness. An appreciation of this immersion in formlessness is eloquently related by award-winning poet and novelist Stephen Dobyns. An insightful essay on the history of swimming photography by European photography critic Hans Christian Adam reaches back to the first images of swimming, documenting how the nineteenth-century camera gingerly followed its human subjects to the water's edge. As enthusiasm for swimming increased, so did the camera's mastery of technique, until finally, swimming photography emerged from the yoke of portraiture and sports to become a significant endeavor in its own right.

In counterpoint to the photographs presented here, a selection of prose and poetry by outstanding contemporary writers offers a kaleidoscopic reflection on the water's lure, in the work of: Theodore Roethke, Derek Walcott, Weldon Kees, Elizabeth Bishop, Pablo Neruda, Ted Mooney, Lou Lipsitz, Robert Mezey, Michael Blumenthal, and others.

THE EDITORS

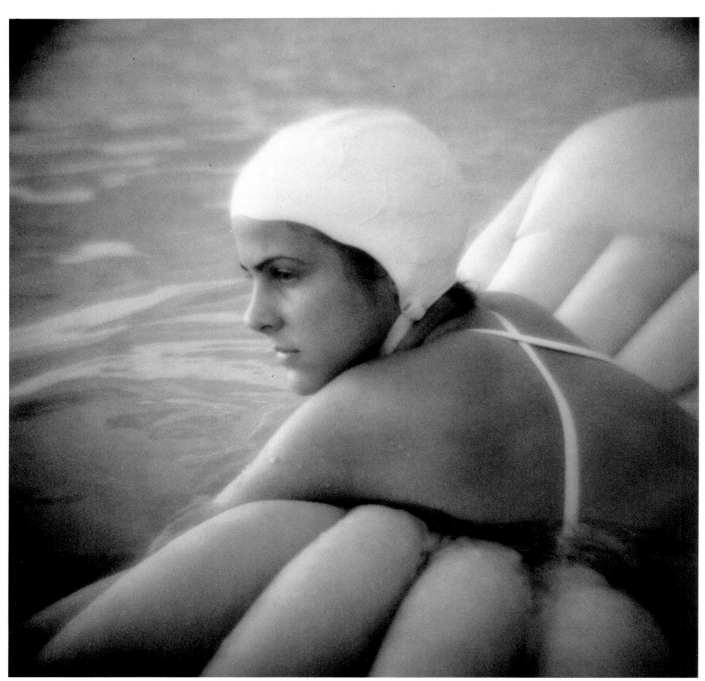

Sally Gall, *Linda*, 1980

SWIMMERS

SEVENTY INTERNATIONAL PHOTOGRAPHERS

Introduction by
Stephen Dobyns

Historical Essay by
Hans Christian Adam

MERMAIDS STEPHEN DOBYNS

In the painting "The Depths of the Sea" by Edward Burne-Jones, the mermaid's arms are wrapped tightly around the young man's waist, pinning his hands behind him. They have sunk far below the surface. The last air bubbles are leaving the man's mouth. His eyes are shut and he appears unconscious. The mermaid's expression is one of proprietary rapture with perhaps a hint of doubt. The man may be hers but he is also dying. The mermaid's golden tail flicks the bottom which seems covered with gold coins. They each had a great desire and that desire has destroyed them.

Burne-Jones's painting captures that element of yearning which the sea can so often bring out in us—the desire to transcend ourselves, to take on another nature, to push aside the laws that bind us, to court a beautiful danger. When swimming, I become graceful. I have put aside my body and have borrowed something from the seal. This is partly why I do it. It doesn't quite allow me to transcend myself, but it gives me a hint of what transcendence might be like. To some degree the water allows us to become what we are not, while giving us a taste of what we can never become.

Years ago I used to swim laps at the YMCA Pool in Cambridge, Massachusetts. One of the other swimmers was blind. He was a college student somewhere. Clumsy, slow, unsure of himself, he didn't so much have a stroke as dozens of jerky motions to propel himself forward. But there was one place where I envied him. On those days when the pool was nearly empty, he would make his way around to the diving board. Slowly, he would climb onto it and begin to feel his way to the end with his toes, keeping his arms stretched out on either side for balance. When he was at last perched on the very tip, he would call out, "Is it all clear?"

If the lifeguard answered yes, the blind swimmer would bounce and leap high into the air—all control gone, arms and legs flapping and kicking, as he broke free for a moment of his mortal body. For an instant he was pure joyous spirit hanging above us. And what a grin he had during those few seconds in the air. So eager was he for his manic dive, that he rarely waited for the all-clear. He would leap wildly off the board, whether there were swimmers beneath him or not, and send us sighted swimmers scrambling for the sides, while he, high above us, momentarily escaped the burden of the physical world.

Gravity is both our protector and jailer and we love those short periods when we are free of it. Plunging through the surf, we gladly let the water lift our weight from us. Adults suddenly have the bodies of children, and children have bodies of air. The physical world has been temporarily defeated. One's mortality diminishes, becomes unimportant. Even the word buoyancy means elasticity of spirit, cheerfulness.

Yet this water can kill us. The ocean's offer to let us become something we are not has its menacing aspect. The young man wrapped in the mermaid's embrace has made a serious mistake. The sirens singing to Odysseus mean him no good; even though they promise wisdom, they intend death. They also sing to Jason and the crew of the Argo in their quest for the golden fleece. Their song is unbounded desire, the desire to leave their bodies and enter a purely sexual element. The oarsmen, hearing the song, turn the Argo toward the reef which would destroy it. Even Jason is defeated. But then Orpheus picks up his lyre and begins to play, setting against the siren's music an even sweeter music, setting structure against cacophony, form against formlessness. Through his music, Orpheus reaffirms the orderly world. The Argo resumes its course. Defeated, the sirens fling themselves into the sea, where they become rocks.

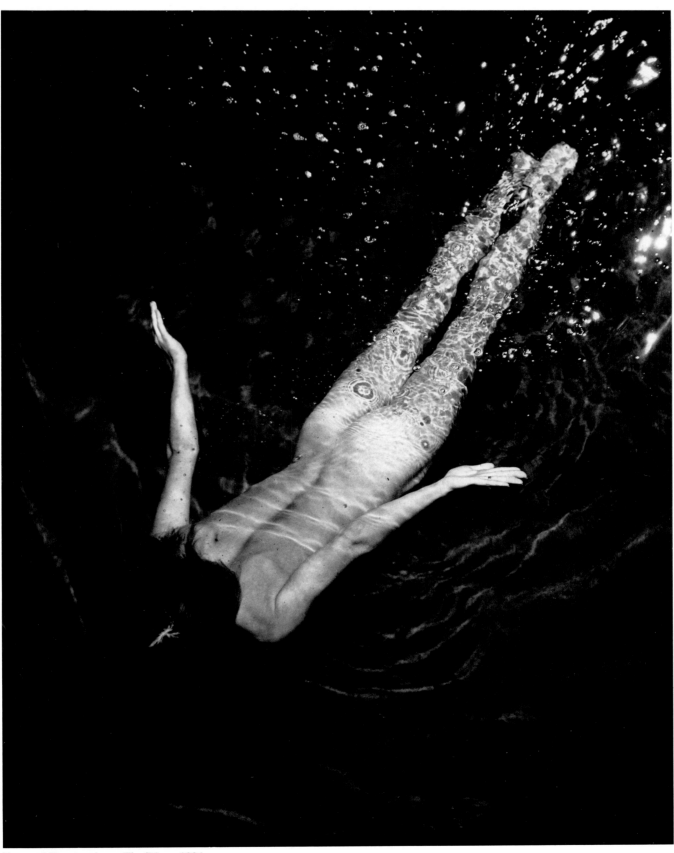

Fernand Fonssagrives, *The Diver*, 1936

But not only is there danger in water, there is mystery. We are quick to believe in mysterious ships, creatures coming out of the depths, strange disappearances. As Percy Bysshe Shelley left Leghorn Harbor in a small sailboat, the mate of another boat observed to Shelley's biographer Trelawny, "Look at those black lines and the dirty rags hanging on them out of the sky—they are a warning; look at the smoke on the water; the devil is brewing mischief."

Shelley's boat sailed into the mist, and that was the last that was ever seen of him. A sudden squall, and nearly four weeks later his body was found washed up on the shore near Via Reggio, his face and hands gone, a copy of Sophocles in one pocket, a copy of Keats in the other. Trelawny built a furnace on the beach and the body was burnt. "The only portions that were not consumed," he wrote, "were some fragment, of bones, the jaw, and the skull, but what surprised us all, was that the heart remained entire. In snatching this relic from the fiery furnace, my hand was severely burnt."

It is hard to look at the water without thinking of people and friends whom we have known who have drowned—a high-school friend tangled in the weeds while scuba diving, a man who fell from his sailboat on a lake in Maine and couldn't swim. We all know people who have gone too far into the water, who have taken one chance too many. Death, too, is a kind of transcendence. It makes the water terrifying and gives it an additional nuance of beauty.

Often in summer I swim in various lakes in New Hampshire and Maine, measuring out a distance of about a mile, then swimming out into the deep water. Usually I can see down about five to ten feet, then all becomes black. It is like swimming over fear itself, swimming over one's unconscious mind. I think of *Jaws* and the shark coming up out of the darkness. Once, in Maine, I saw an eel about six feet long curled up on the bottom of a lake. Its terror on seeing me was far greater than mine, but for a moment my fear was so primitive that I nearly scrambled for land. But even the eel felt like something deep within me, a projection of my unconscious, as if by erasing my body in the water, the lake had become an extension of myself. Swimming over such a darkness, I always felt on the very brink of learning something important, something to change my life.

In many ways, the photographs in this collection all deal with transcendence, the body triumphing over gravity, of defeating for a short time its mortal cage. How graceful these bodies become. Even the fat boy running down the beach seems ready to fly. And the old man drifting on a float has escaped himself for an afternoon. Picture after picture shows people of all ages leaping into the waves, as if intending to reverse the process of evolution. They dive into the water as if returning home—eager, excited, exhilarated. It takes their breath. They leave their lumpish selves and enter their beautiful selves. They exist at the very edge of being human. Several photographs show boys so covered with sand that they look like statues erected to their own memories. These water-goers hope to push beyond their quotidian lives, to forget the sunburns, the sand in their sandwiches, the long drive home through heavy traffic.

The subject of these photographs is also timelessness. There is no past or future at the beach. It is a time-out period. Beyond that, the waves have counted out the seconds since the beginning, yet it's as if each second and wave were the same moment, repeated over and over. Entering the water we leave time behind, we defeat the world. Perhaps

that is why there is so much joy in these pictures. Constant laughter, constant smiles—
the joy at having briefly escaped our mortal destiny.

The photographs are also about space—the small, puny, soft body poised against
the seemingly endless ocean and sky: a woman holding her child as she stares into
the blue nothingness; three boys dashing out into the infinite; several girls on a white
raft silhouetted against the massive dark of the night. They show the human, the
small, at the very edge of limitlessness, taunting it, playing with it, losing one's self
in it.

Water is purifying. Stepping into it, the world of gravity is washed from us. All
our stains come clean; our griefs and difficulties are temporarily forgotten. In entering
the timelessness of the water, we, too, for a brief space, become without a past. This
strengthens us and we return to the world eager and even optimistic about the struggle.
The ocean, or so we used to imagine, cannot be dirtied. An early discredited saint,
St. Murgen, was a mermaid who had been caught and baptized in northern Wales,
and then spent her life doing good works. Having come from the sea, she seemed
specially equipped to cleanse the world.

We like to imagine that no matter how life has sullied us, the water can make us
pure again. It is almost as if we are receiving the forgiveness of the world. We are
being given another chance, a secular baptism. Pablo Neruda wrote a wonderful poem
of a mermaid, trapped and dirtied on land, who has only to return to the water to be
cleansed. It brings us full circle: Burne-Jones's mermaid with the man as her victim;
Neruda's mermaid who is the victim of the drunks. And again we are in the presence
of mystery.

FABLE OF THE MERMAIDS AND THE DRUNKS

All these gentlemen were there inside
when she entered, utterly naked.
They had been drinking, and began to spit at her.
Recently come from the river, she understood nothing.
She was a mermaid who had lost her way.
The taunts flowed over her glistening flesh.
Obscenities drenched her golden breasts.
A stranger to tears, she did not weep.
A stranger to clothes, she did not dress.
They pocked her with cigarette ends and with burnt corks,
and rolled on the tavern floor with laughter.
She did not speak, since speech was unknown to her.
Her eyes were the color of faraway love,
her arms were matching topazes.
Her lips moved soundlessly in coral light,
and ultimately, she left by that door.
Scarcely had she entered the river than she was cleansed,
gleaming once more like a white stone in the rain;
and without a backward look, she swam once more,
swam toward nothingness, swam to her dying.

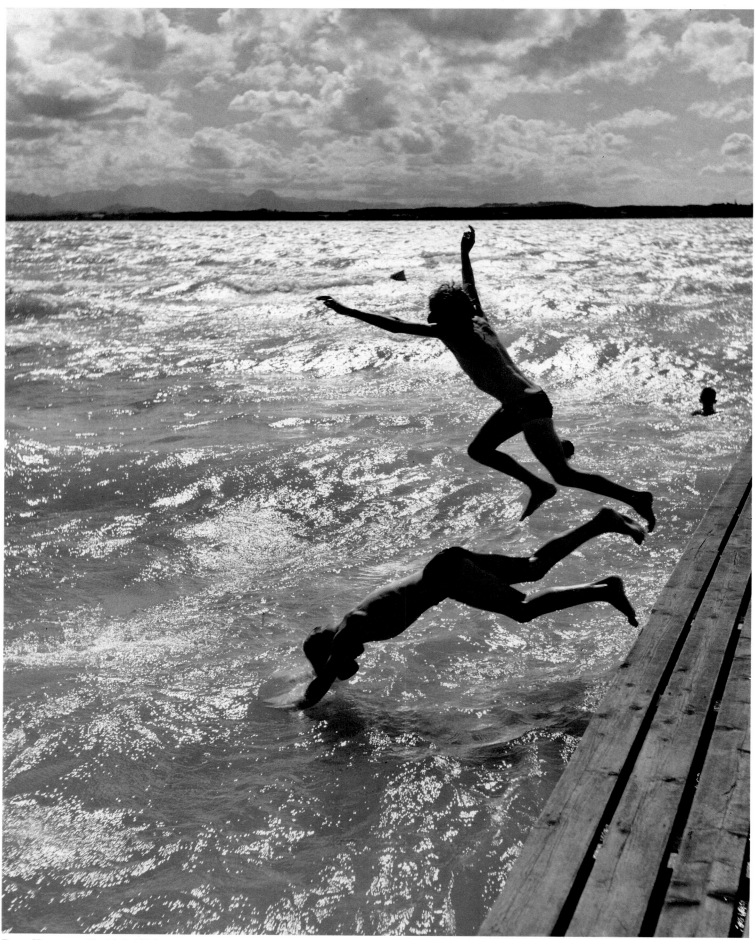

Peter Keetman, *Untitled*, 1956

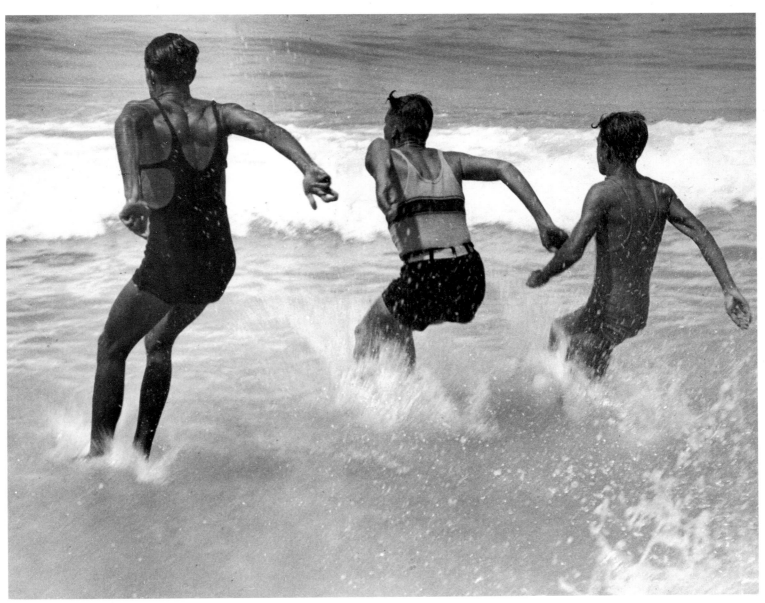

Martin Munkacsi, *Badende (Bathing)*, 1929

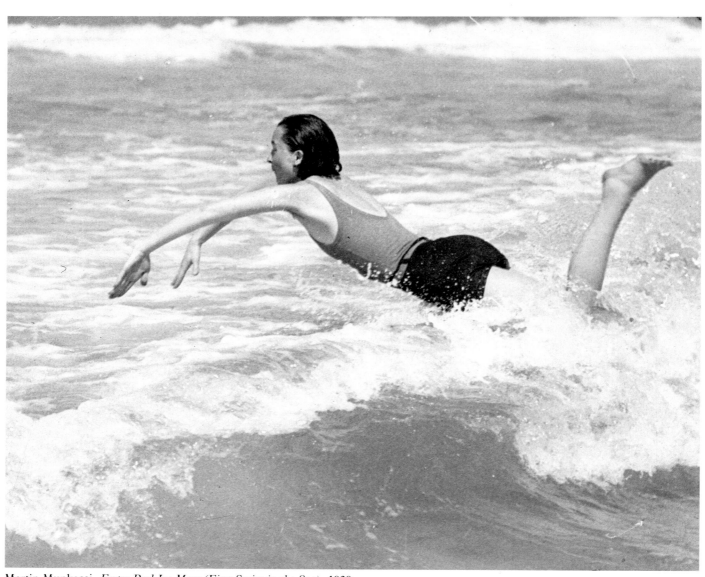

Martin Munkacsi, *Erstes Bad Im Meer (First Swim in the Sea)*, 1929

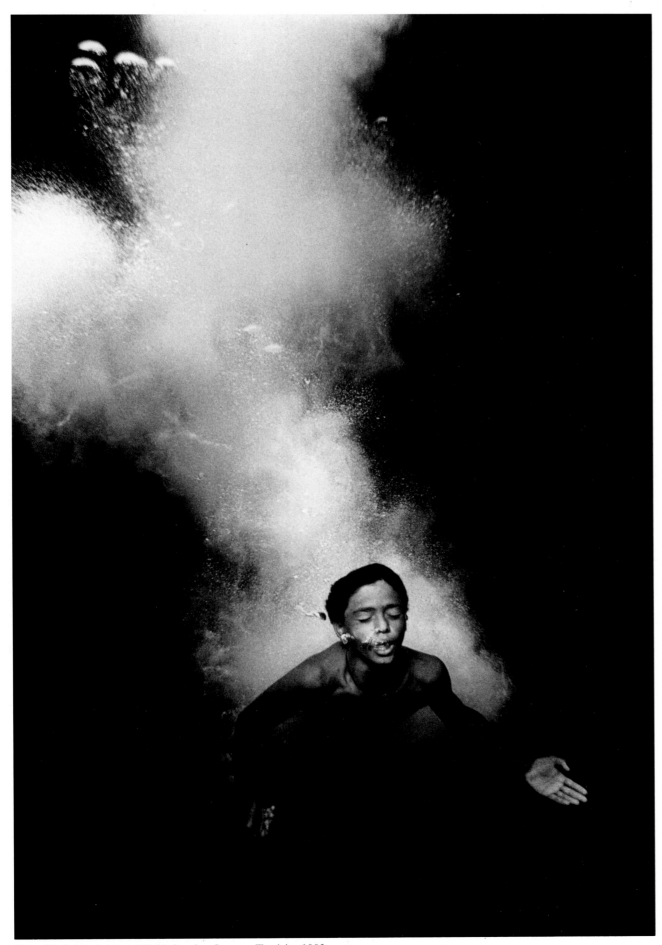

Hans Christian Adam, *MS Mabrouka*, Sousse, Tunisia, 1982

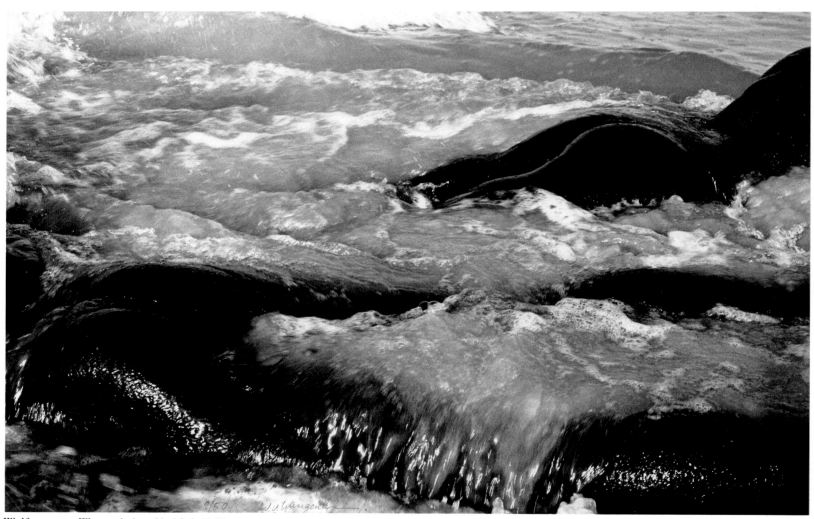

Wolfgang von Wangenheim, *Untitled*, 1977

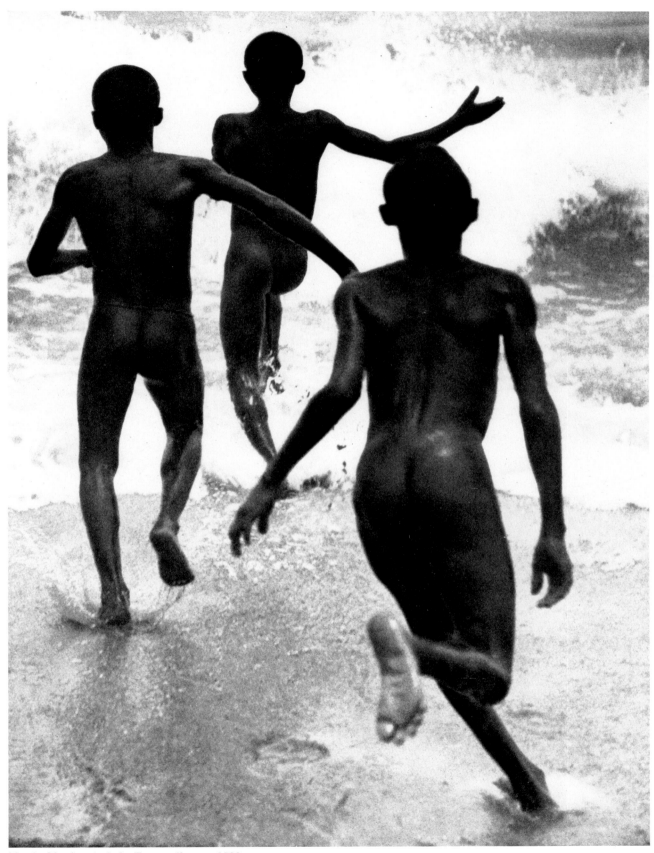

Martin Munkacsi, *Lake Tanganyika*, ca. 1930

SEXUAL WATER

Rolling in big solitary raindrops,
in drops like teeth,
in big thick drops of marmalade and blood,
rolling in big raindrops,
the water falls,
like a sword in drops,
like a tearing river of glass,
it falls biting,
striking the axis of symmetry, sticking to the
 seams of the soul,
breaking abandoned things, drenching the dark.

It is only a breath, moister than weeping,
a liquid, a sweat, a nameless oil,
a sharp movement,
forming, thickening,
the water falls,
in big slow raindrops,
toward its sea, toward its dry ocean,
toward its waterless wave.

I see the vast summer, and a death rattle
 coming from a granary
stores, locusts,
towns, stimuli,
rooms, girls
sleeping with their hands upon their hearts,
dreaming of bandits, of fires,
I see ships,
I see marrow trees
bristling like rabid cats,
I see blood, daggers, and women's stockings,
and men's hair,
I see beds, I see corridors where a virgin screams,
I see blankets and organs and hotels.

I see the silent dreams,
I accept the final days,
and also the origins, and also the memories,
like an eyelid atrociously and forcibly uplifted
I am looking.

And then there is this sound:
a red noise of bones,
a clashing of flesh,
and yellow legs like merging spikes of grain.
I listen among the smack of kisses,
I listen, shaken between gasps and sobs.
I am looking, hearing,
with half my soul upon the sea and half my soul
 upon the land,
and with the two halves of my soul I look
 at the world.

And though I close my eyes and cover
 my heart entirely,
I see a muffled waterfall,
in big muffled raindrops.
It is like a hurricane of gelatine,
like a waterfall of sperm and jellyfish.
I see a turbid rainbow form.
I see its waters pass across the bones.

PABLO NERUDA

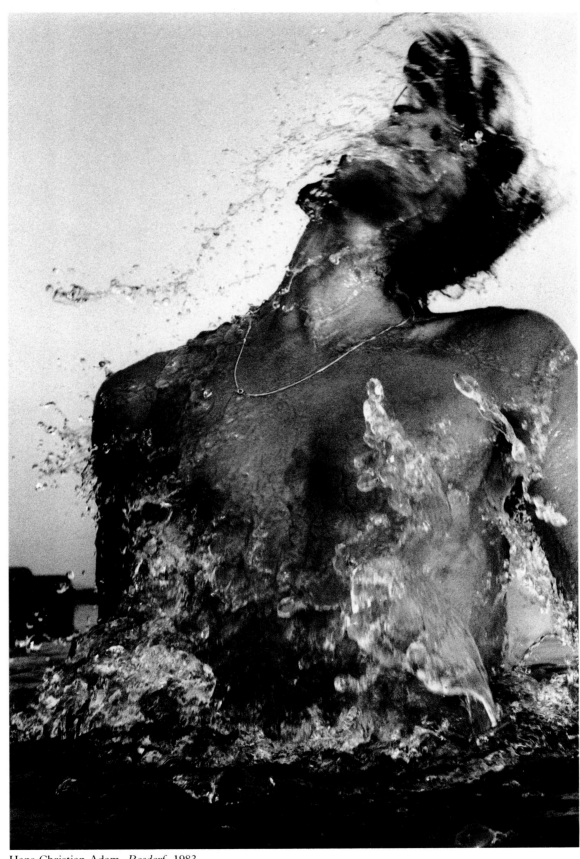

Hans Christian Adam, *Rosdorf*, 1983

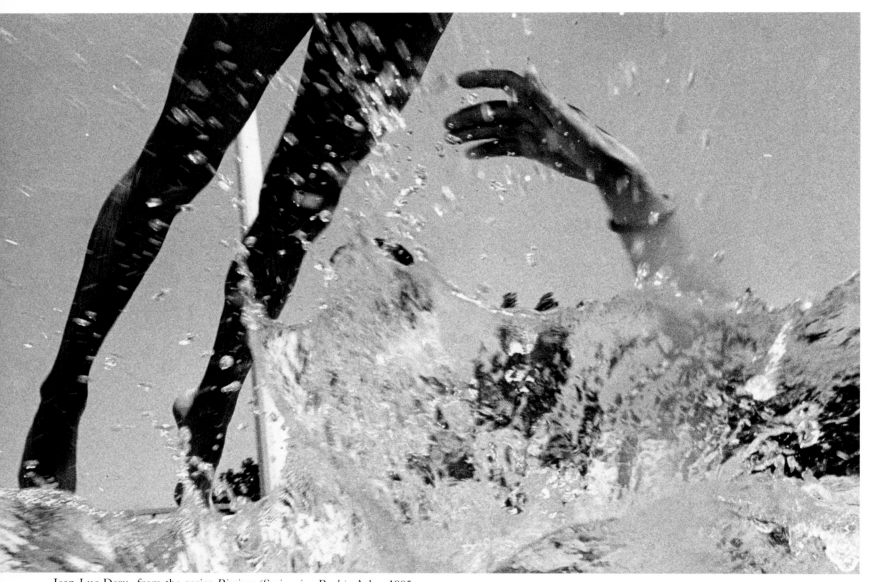

Jean-Luc Deru, from the series *Piscines (Swimming Pools)*, Arles, 1985

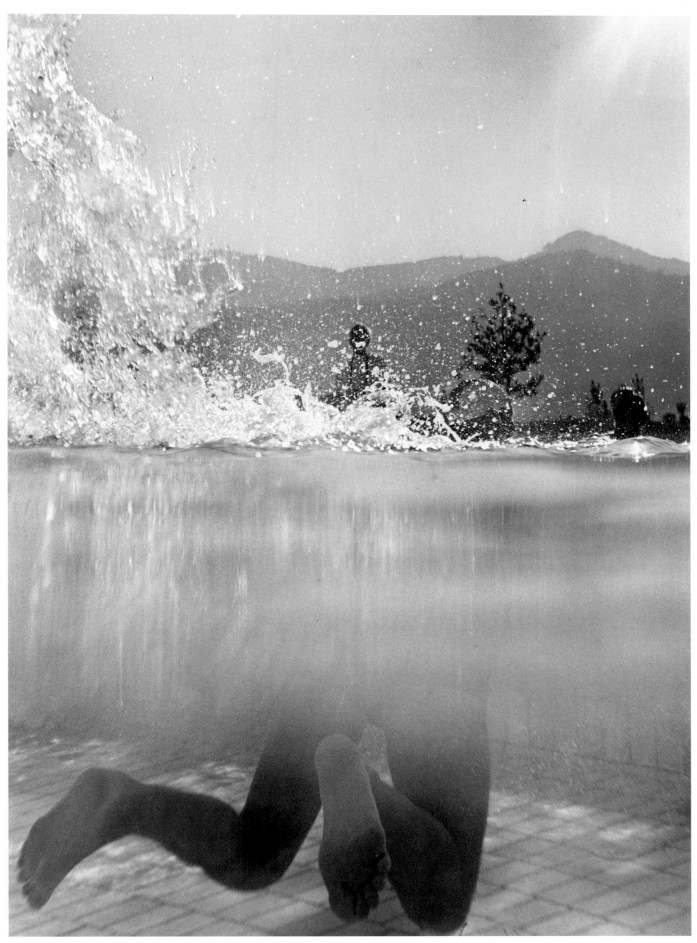

Christopher Poehlmann, *Salzburg, Austria, 1985*

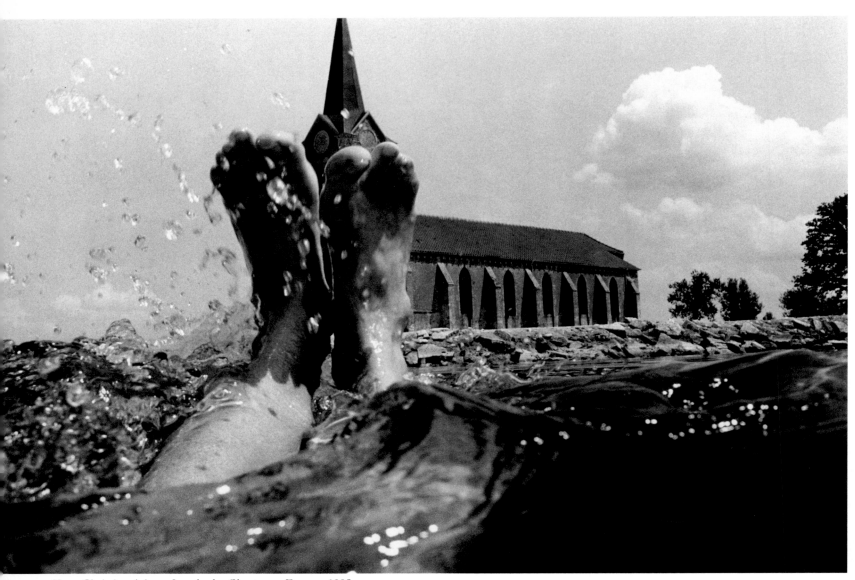

Hans Christian Adam, *Lac du der Chantecoq*, France, 1985

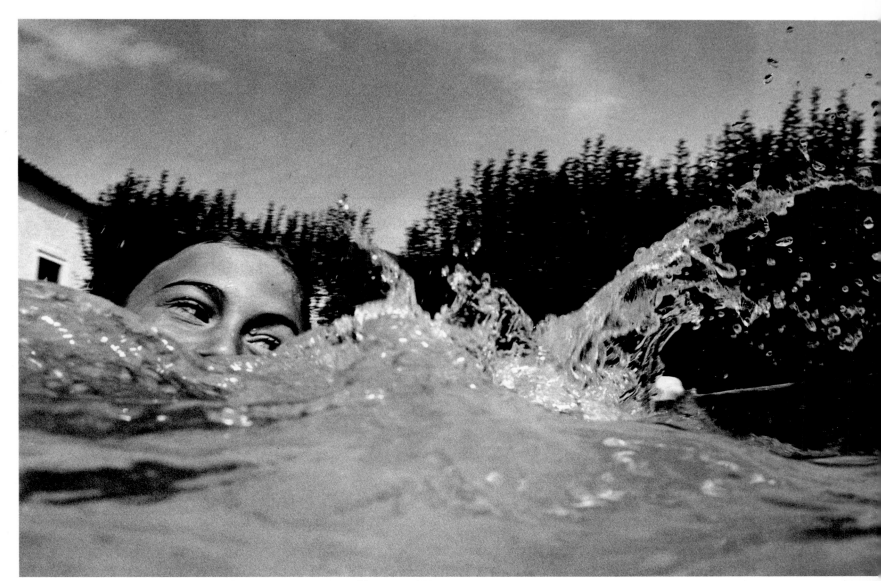

Jean-Luc Deru, from the series *Piscines (Swimming Pools)*, Pas de Ventoux, 1982

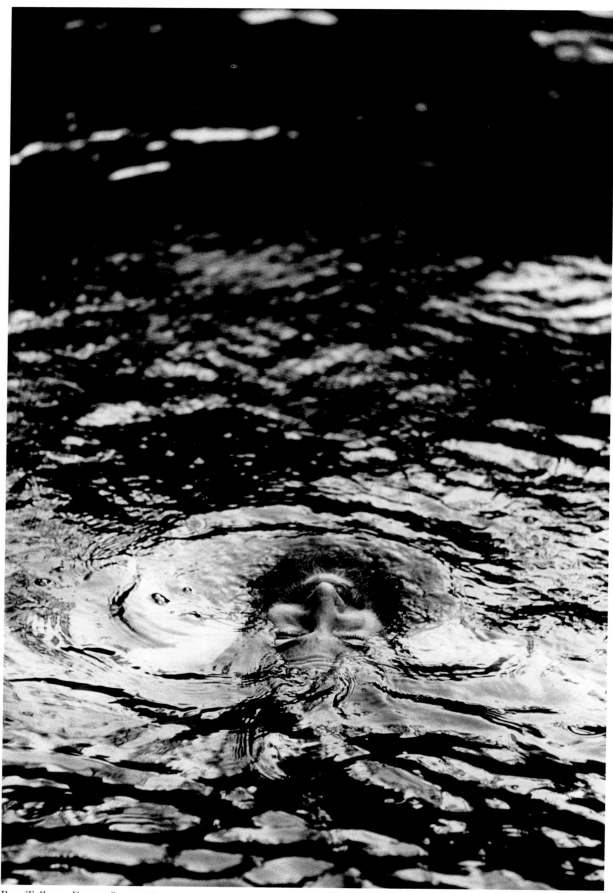

Ron Talbott, *Fotografie*, ca. 1978

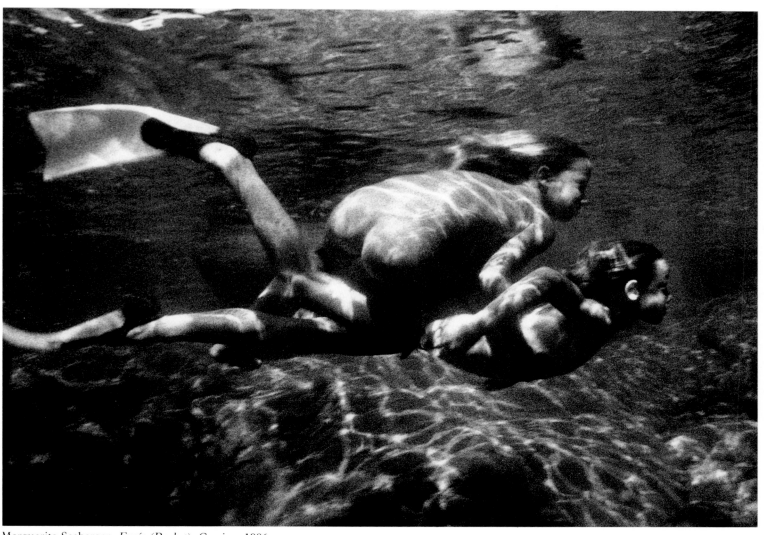

Marguerite Seeberger, *Fusée (Rocket)*, Corsica, 1986

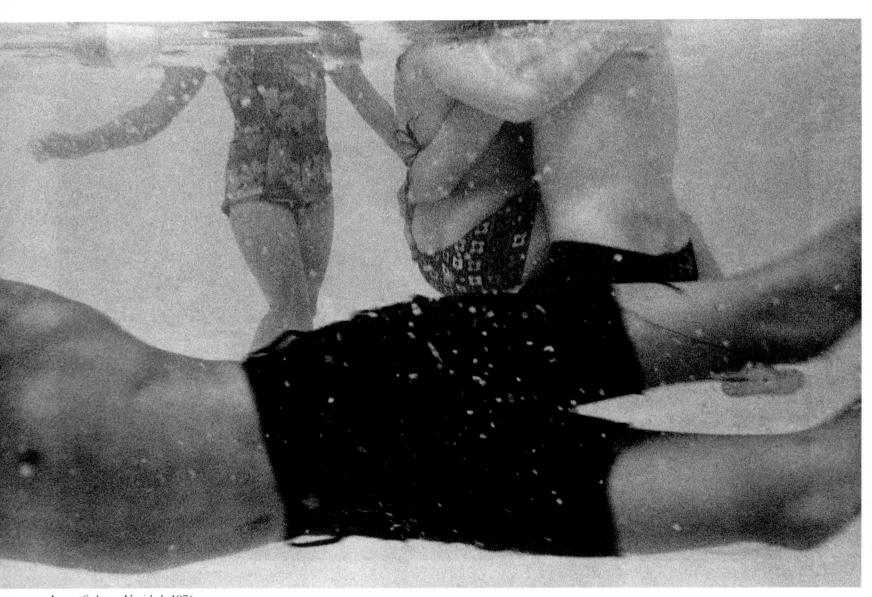

Larry Sultan, *Untitled*, 1976

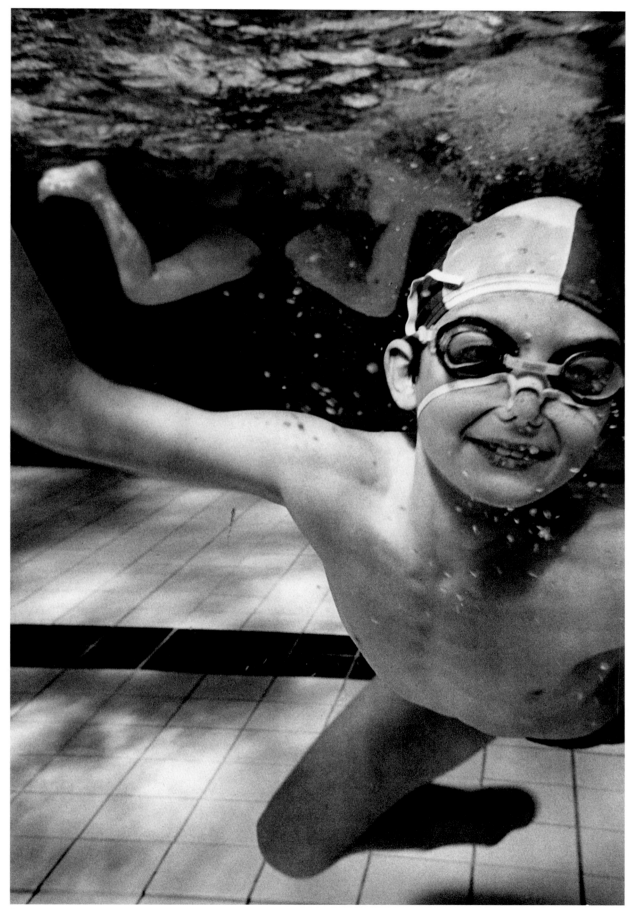

Jean-Luc Deru, from the series *Piscines (Swimming Pools)*, Serieng, 1977

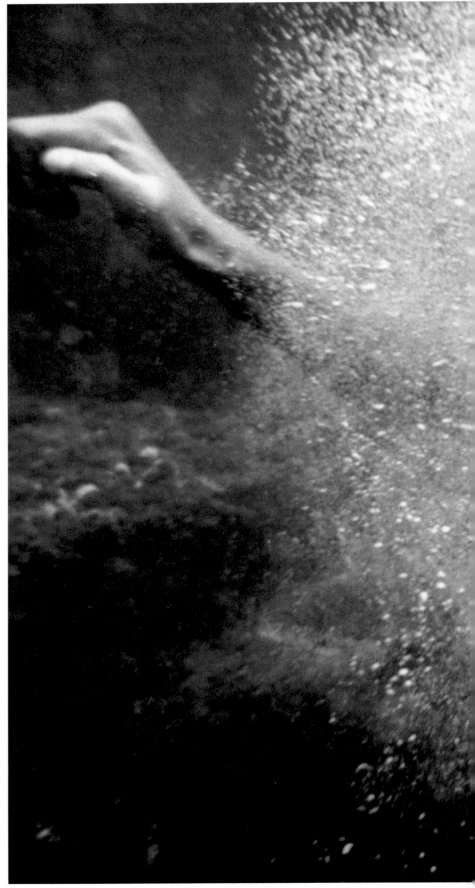

Before descending to the alluvial plain,
To the clay banks, and the wild grapes hanging from
 the elmtrees.
The slightly trembling water
Dropping a fine yellow silt where the sun stays;
and the crabs bask near the edge,
The weedy edge, alive with small snakes and
 bloodsuckers–
I have come to a still, but not a deep center,
A point outside the glittering current;
My eyes stare at the bottom of a river,
At the irregular stones, iridescent sandgrains,
My mind moves in more than one place,
In a country half-land, half-water. . . .

The lost self changes,
Turning toward the sea,
A sea-shape turning around–
An old man with his feet before the fire,
In robes of green, in garments of adieu.

A man faced with his own immensity
Wakes all the waves, all their loose wandering fire.
The murmur of the absolute, the why
Of being born fails on his naked ears.
His spirit moves like monumental wind
That gentles on a sunny blue plateau.
He is the end of things, the final man.

THEODORE ROETHKE, from *The Meadow Mouse*

Marie-Paule Négre, *St. Nandier sur Mer,* 1986

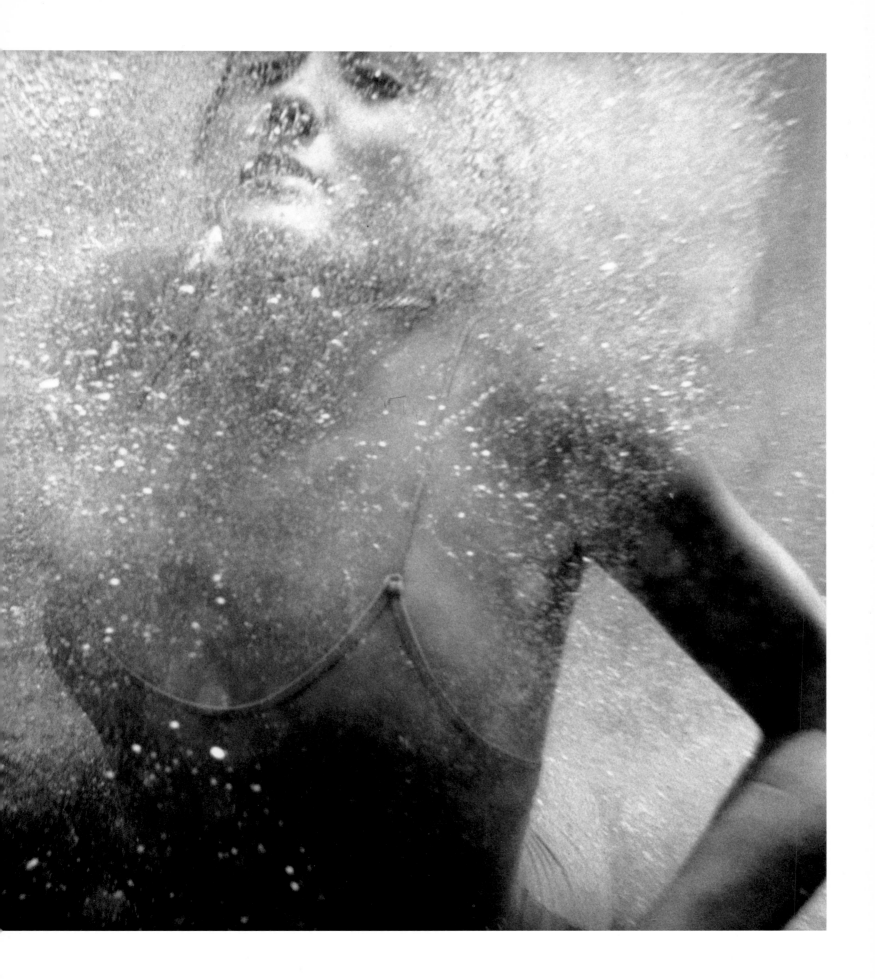

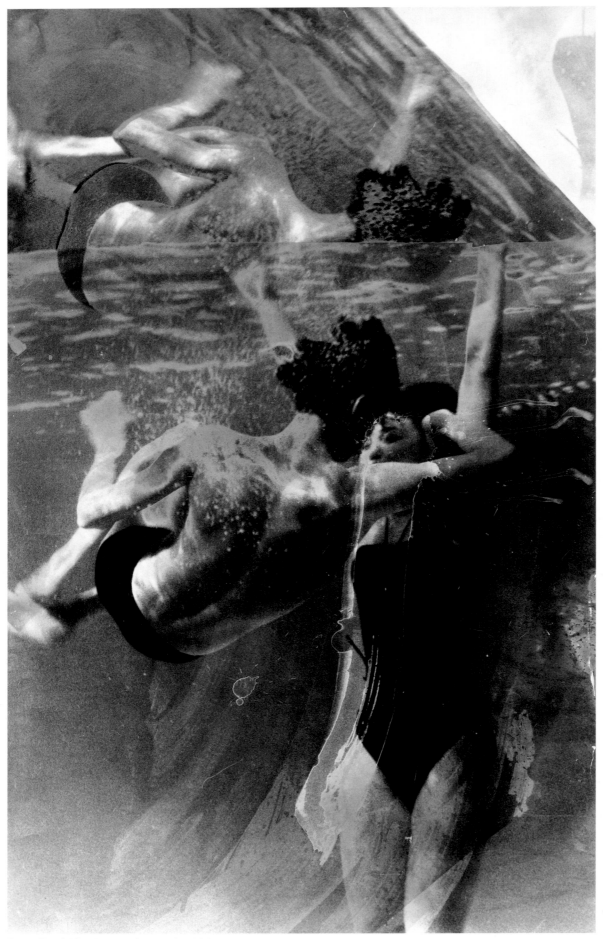

Dörte Eissfeldt, *Transitorium #10*, 1984

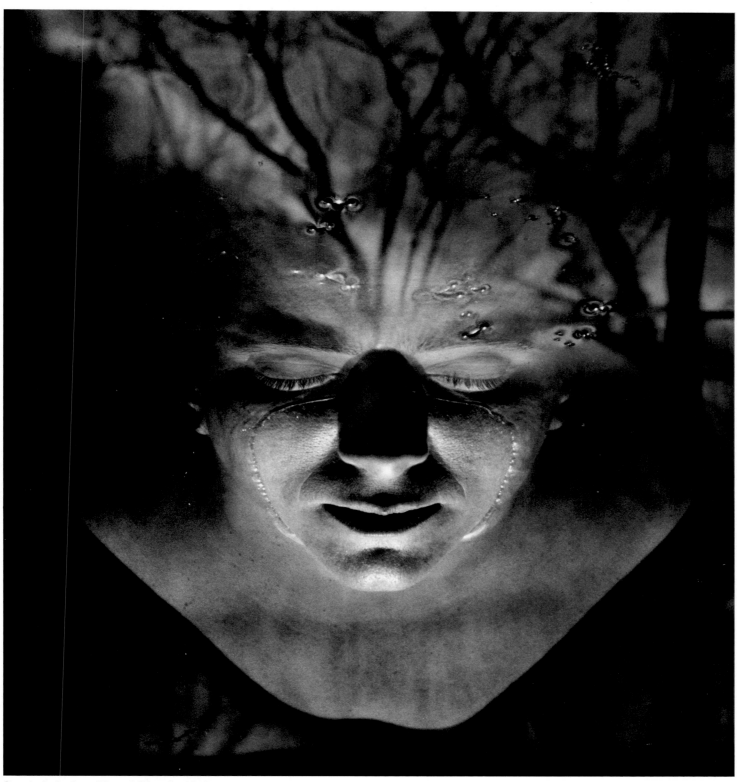

Connie Imboden, *Visceral Thought*, 1987

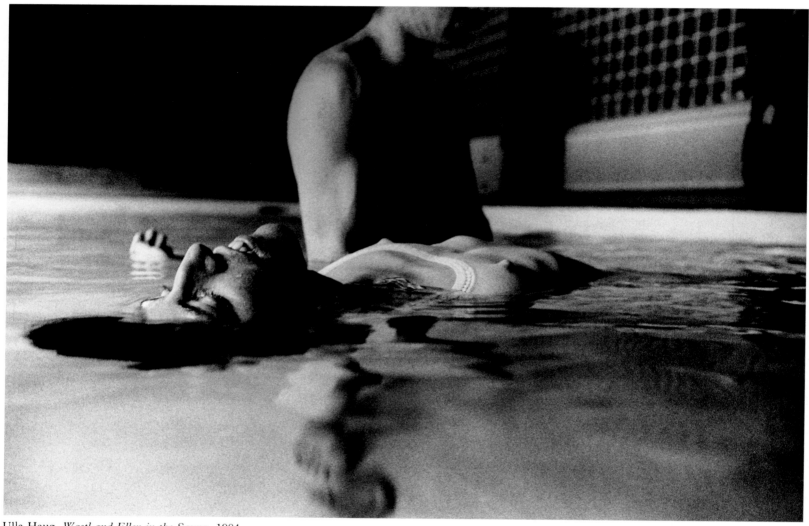

Ulla Haug, *Wastl and Ellen in the Sauna*, 1984

For Naomi, later

I want to speak to you while I can,
in your fourth year before you can well understand,
before this river
white and remorseless carries me away.

You asked me to tell you about death.
I said nothing. I said

This is your father,
this is your father like water,
like fate,
like a feather circling down.

And I am my own daughter
swimming out,
a phosphorescence on the dark face of the surf.

A boat circling on the darkness.

ROBERT MEZEY from *I Am Here*

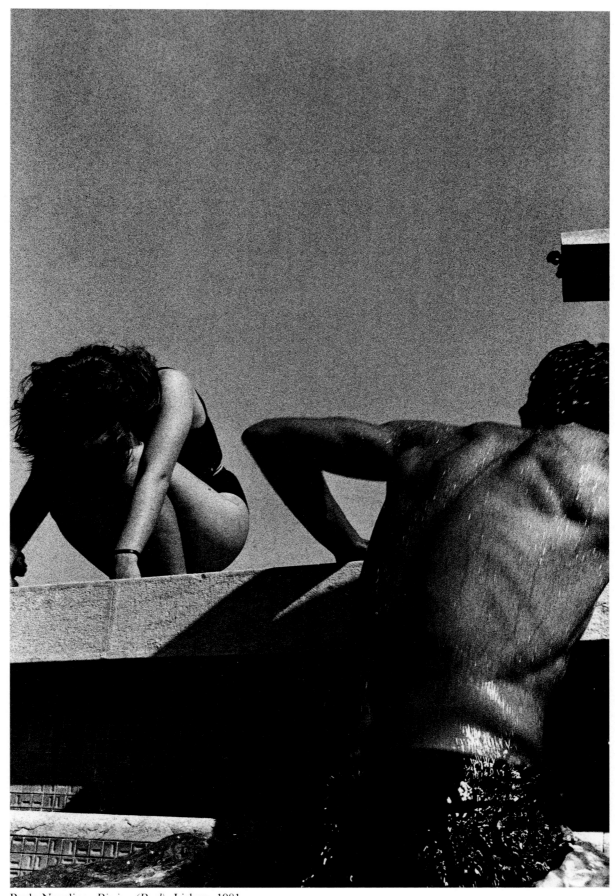

Paulo Nozolino, *Piscina (Pool)*, Lisbon, 1981

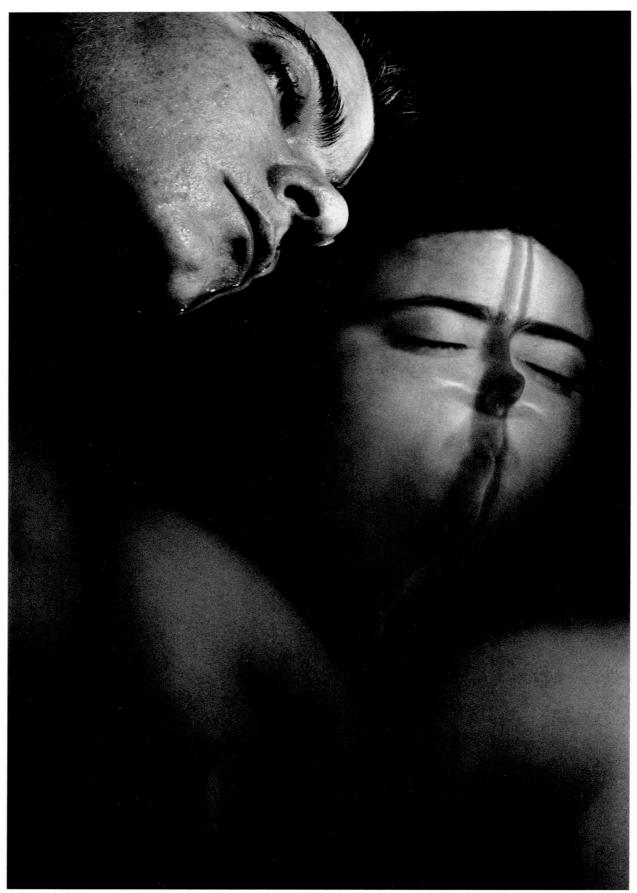

Connie Imboden, *Mother and Child*, 1987

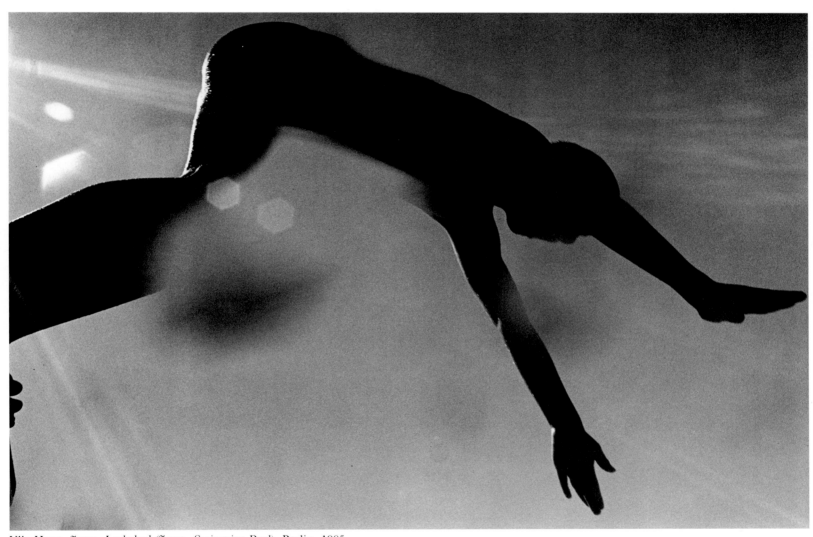

Ulla Haug, *Jump, Lochobad (Jump, Swimming Pool)*, Berlin, 1985

PAEAN TO PLACE

And the place was water

Fish
 fowl
 flood
 Water lily mud
My life

in the leaves and on water
My mother and I
 born
in swale and swamp and sworn
to water

My father
thru marsh fog
 sculled down
 from high ground
saw her face

at the organ
bore the weight of lake water
 and the cold—
he seined for carp to be sold
that their daughter

might go high
on land
 to learn
Saw his wife turn
deaf

and away
She
 who knew boats
 and ropes
no longer played

She helped him string out nets
for tarring
 And she could shoot
 He was cool
to the man

who stole his minnows
by night and next day offered
 to sell them back
 He brought in a sack
of dandelion greens

if no flood
No oranges—none at hand
 No marsh marigolds
 where the water rose
He kept us afloat

I mourn her not hearing canvasbacks
their blast-off rise
 from the water
 Not hearing sora
rail's sweet

spoon-tapped waterglass-
descending scale-
 tear-drop-tittle
 Did she giggle
as a girl?

His skiff skimmed
the coiled celery now gone
 from these streams
 due to carp
He knew duckweed

I lost you to water, summer
when the young girls swim,
to the hot shore
to little peet-tweet-
 pert girls.

Now it's cold your bright knock
—Orion's with his dog after him—
at my door, boy
on a winter
 wave ride.

LORINE NIEDECKER

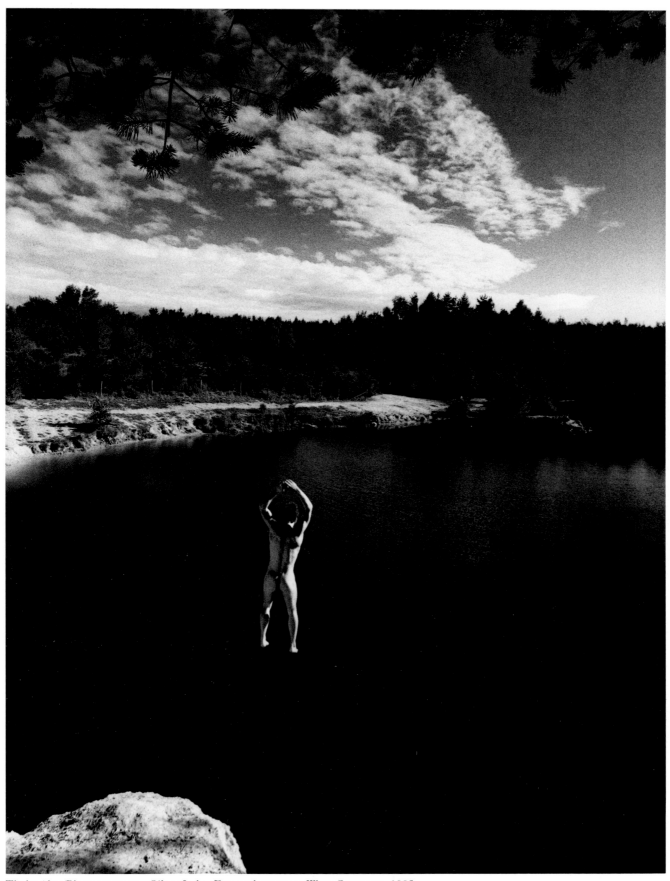

Thelen/dpa/Photoreporters, *Silver Lake*, Eppertshausener, West Germany, 1985

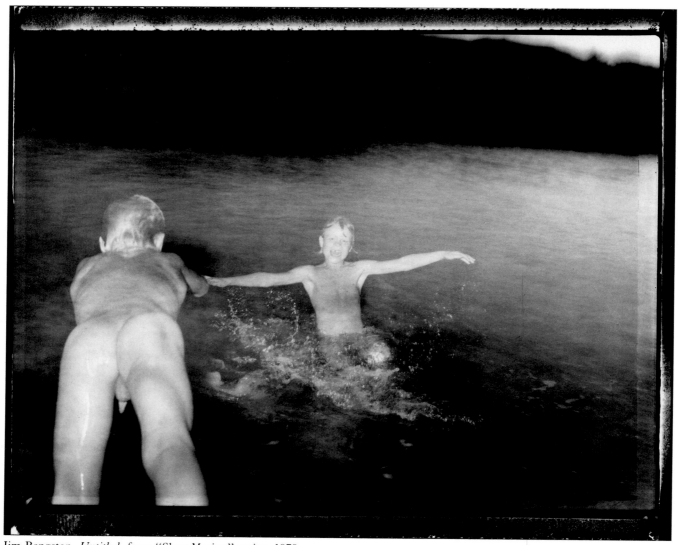

Jim Bengston, *Untitled*, from "Slow Motion" series, 1979

Cold water on my bare feet.
You are like cold water.

All day I've watched the water
run from the tap, splash into the bushes
where the earth awaits it
and sucks it up.

Cold water! The grass exclaims.

LOU LIPSITZ

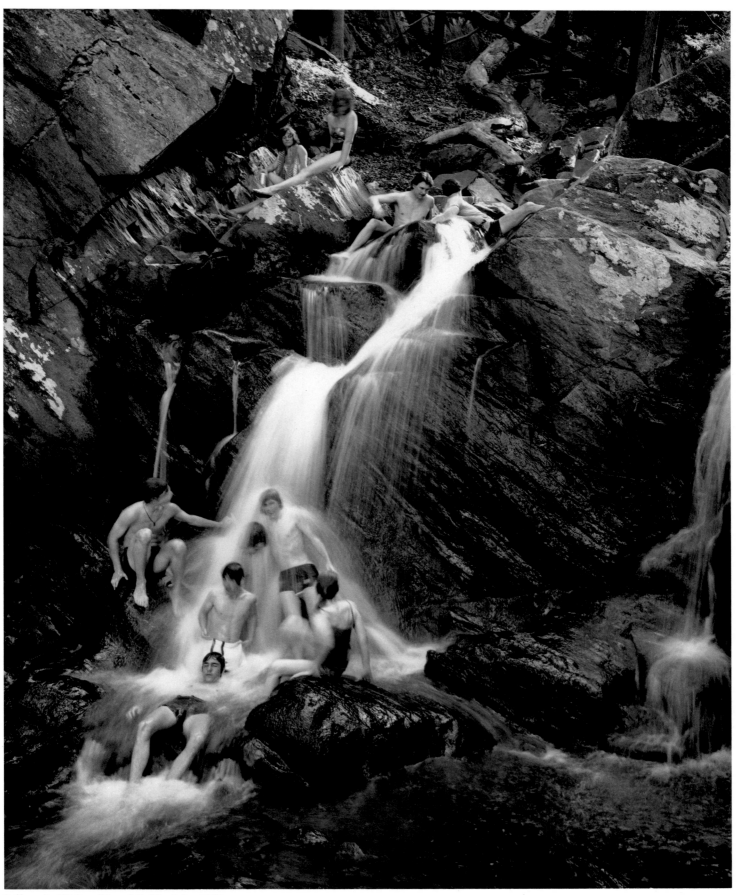

Jeffrey A. Wolin, *Waterfall*, Virginia, 1982

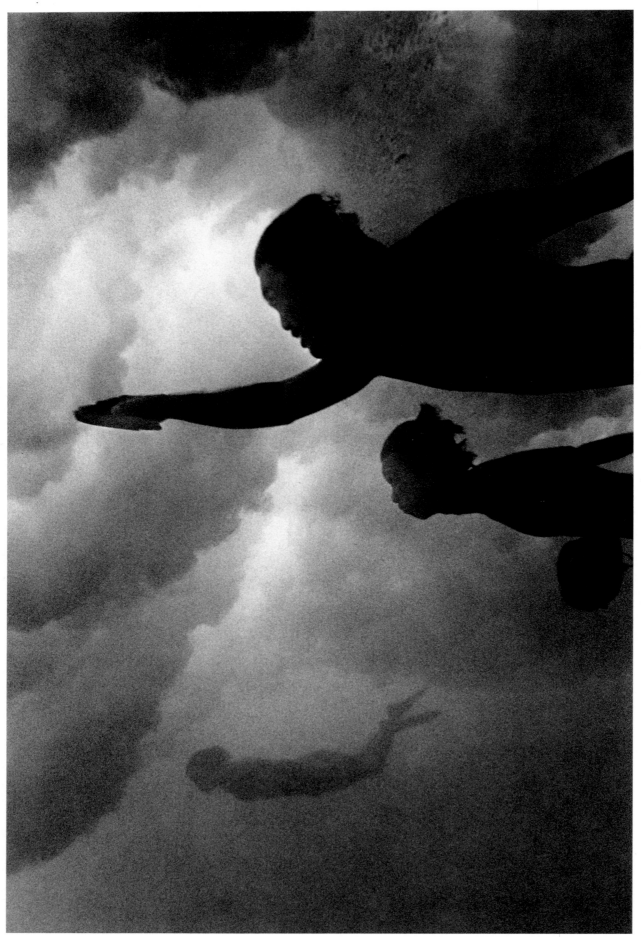

Wayne Levin, *Untitled #1*, from "The Underwater Surfing Series," Makapuu, Oahu, Hawaii, 1983

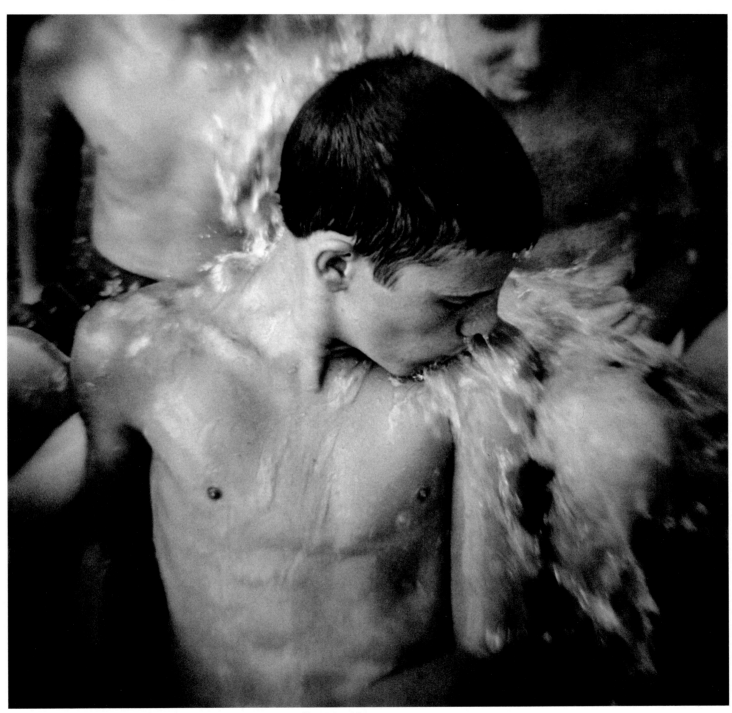

M.K. Simqu, *Three*, from the series "Bather and Waters," 1979–1986

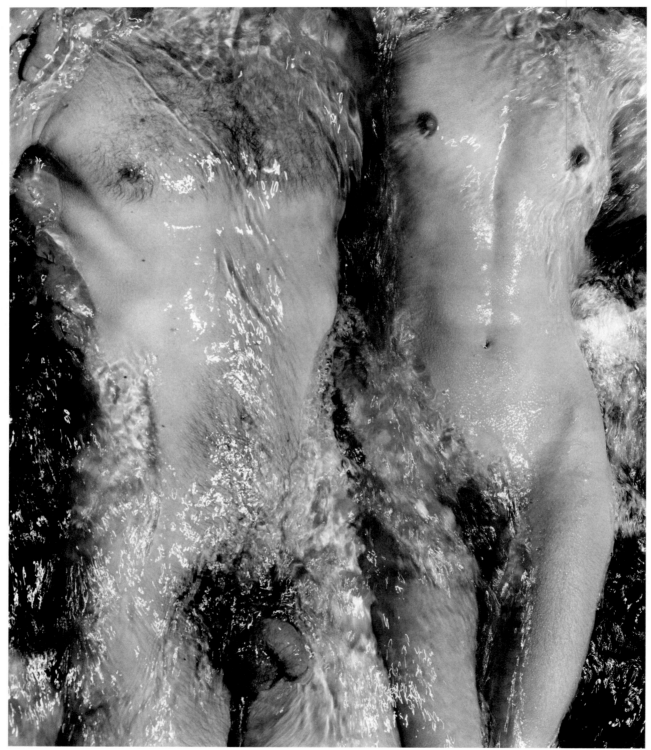

Bob Saltzman, *In the River from Blue Lake*, 1986

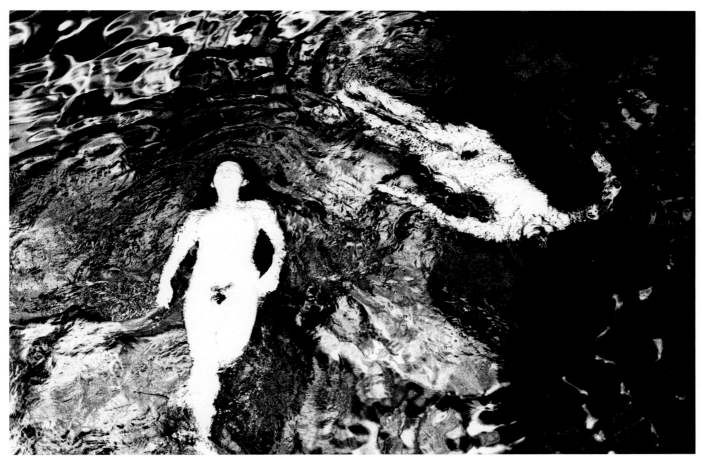

Stephen Fiorella, *Untitled*, from the series "Swimmers," 1978–1987

THE NUDE SWIM

On the southwest side of Capri
we found a little unknown grotto
where no people were and we
entered it completely
and let our bodies lose all
their loneliness.

All the fish in us
had escaped for a minute.
The real fish did not mind.
We did not disturb their personal life.
We calmly trailed over them
and under them, shedding
air bubbles, little white
balloons that drifted up
into the sun by the boat
where the Italian boatman slept
with his hat over his face.

Water so clear you could
read a book through it.

Water so buoyant you could
float on your elbow.
I lay on it as on a divan.
I lay on it just like
Matisse's Red Odalisque.
Water was my strange flower.
One must picture a woman
without a toga or a scarf
on a couch as deep as a tomb.

The walls of that grotto
were everycolor blue and
you said, "Look! Your eyes
are seacolor. Look! Your eyes
are skycolor." And my eyes
shut down as if they were
suddenly ashamed.

ANNE SEXTON

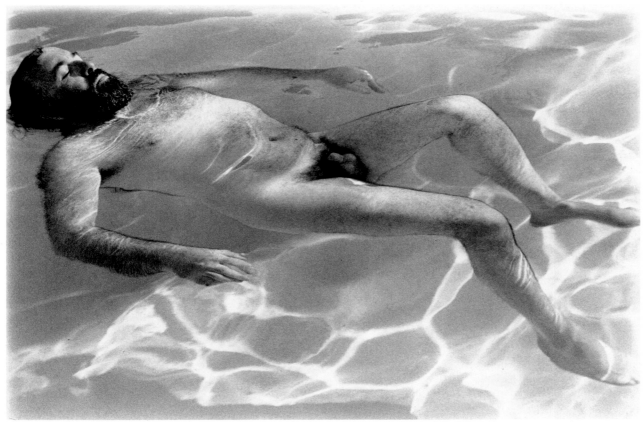

Becky Cohen, *Swimmer*, 1984

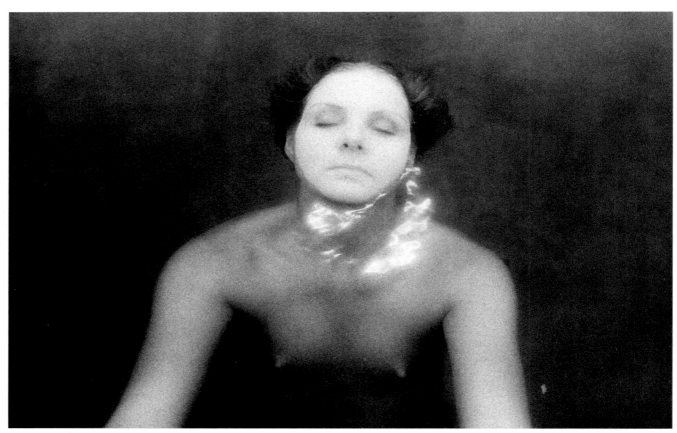

Abigail Perlmutter, *Joanne Swimming*, 1978

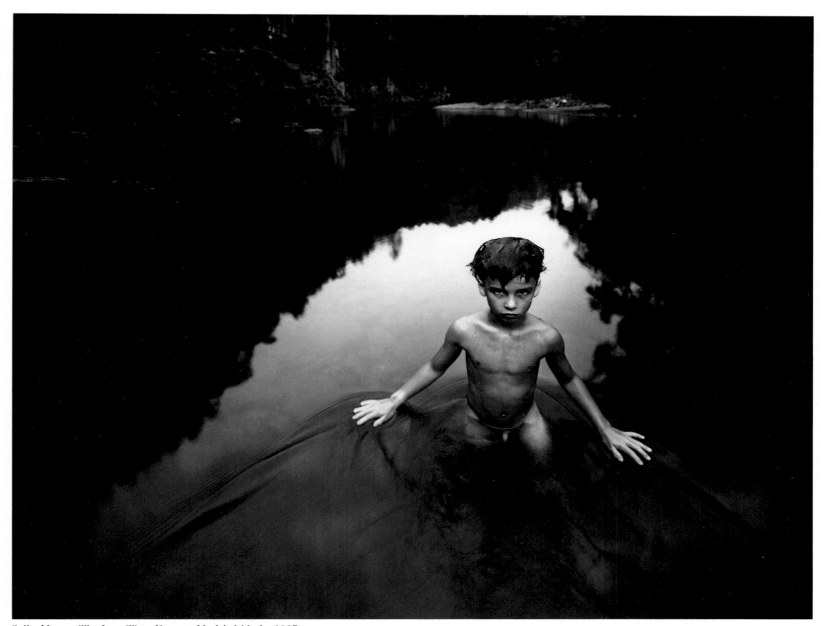

Sally Mann, *The Last Time Emmett Modeled Nude*, 1987

THE LIFEGUARD

In a stable of boats I lie still,
From all sleeping children hidden.
The leap of a fish from its shadow
Makes the whole lake instantly tremble.
With my foot on the water, I feel
The moon outside

Take on the utmost of its power.
I rise and go out through the boats.
I set my broad sole upon silver,
On the skin of the sky, on the moonlight,
Stepping outward from earth onto water
In quest of the miracle

This village of children believed
That I could perform as I dived
For one who had sunk from my sight.
I saw his cropped haircut go under.
I leapt, and my steep body flashed
Once, in the sun.

Dark drew all the light from my eyes.
Like a man who explores his death
By the pull of his slow-moving shoulders,
I hung head down in the cold,
Wide-eyed, contained, and alone
Among the weeds.

And my fingertips turned into stone
From clutching immovable blackness.
Time after time I leapt upward
Exploding in breath, and fell back
From the change in the children's faces
At my defeat.

Beneath them I swam to the boathouse
With only my life in my arms
To wait for the lake to shine back

At the risen moon with such power
That my steps on the light of the ripples
Might be sustained.

Beneath me is nothing but brightness
Like the ghost of a snowfield in summer.
As I move toward the center of the lake,
Which is also the center of the moon,
I am thinking of how I may be
The savior of one

Who has already died in my care.
The dark trees fade from around me.
The moon's dust hovers together.
I call softly out, and the child's
Voice answers through blinding water.
Patiently, slowly,

He rises, dilating to break
The surface of stone with his forehead.
He is one I do not remember
Having ever seen in his life.
The ground I stand on is trembling
Upon his smile.

I wash the black mud from my hands.
On a light given off by the grave
I kneel in the quick of the moon
At the heart of a distant forest
And hold in my arms a child
Of water, water, water.

JAMES DICKEY

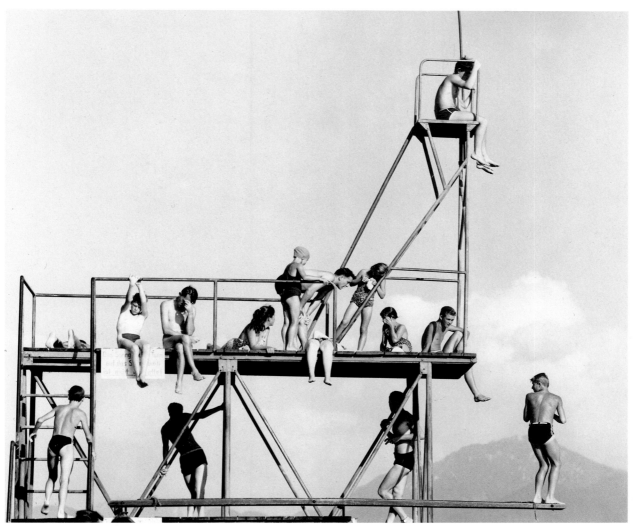

Peter Keetman, *Untitled*, 1957

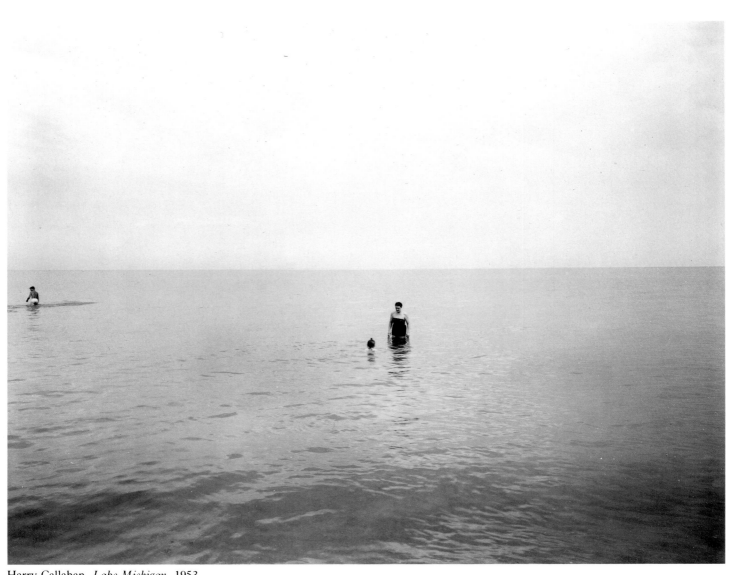

Harry Callahan, *Lake Michigan*, 1953

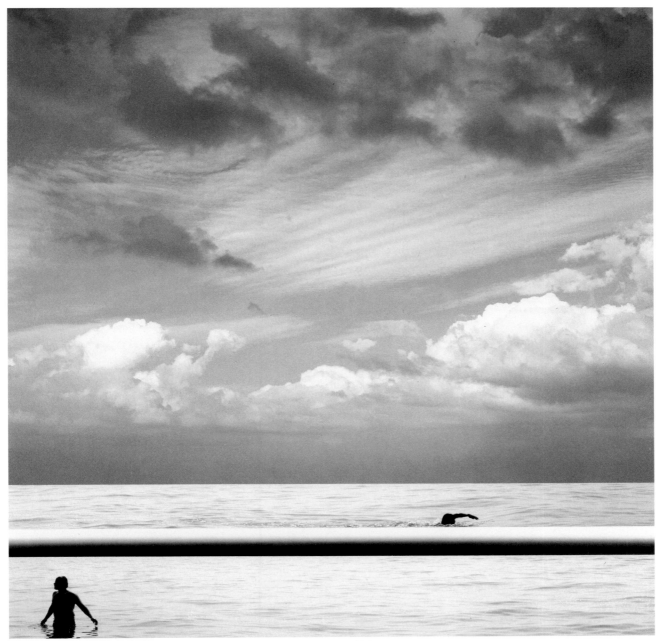

Steven D. Foster, *Untitled*, from "The Lake Series," Milwaukee, 1981

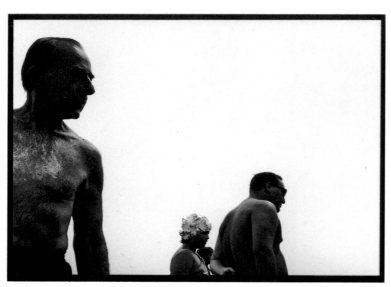 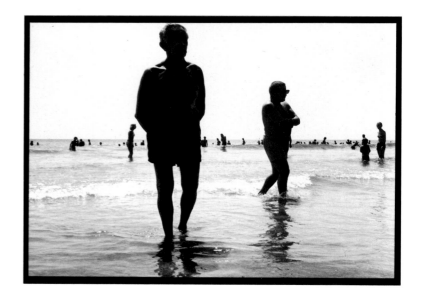

Ray Metzker, from the series *Sand Creatures*, 1971–1975

PLEASURE SEAS

In the walled off swimming-pool the water is perfectly flat.
The pink Seurat bathers are dipping themselves in and out
Through a pane of bluish glass.
The cloud reflections pass
Huge amoeba-motions directly through
The beds of bathing caps: white, lavender, and blue.
If the sky turns gray, the water turns opaque,
Pistachio green and Mermaid Milk.
But out among the keys
Where the water goes its own way, the shallow pleasure seas
Drift this way and that mingling currents and tides
In most of the colors that swarm around the sides
Of soap-bubbles, poisonous and fabulous.
And the keys float lightly like rolls of green dust.
From an airplane the water's heavy sheet
Of glass above a bas-relief:

Clay-yellow coral and purple dulces
And long, leaning, submerged green grass.
Across it a wide shadow pulses.
The water is a burning-glass
Turned to the sun
That blues and cools as the afternoon wears on,
And liquidly
Floats weeds, surrounds fish, supports a violently red bell-buoy
Whose neon-color vibrates over it, whose bells vibrate
Through it. It glitters rhythmically
To shock after shock of electricity
The sea is delight. The sea means room.
It is a dance-floor, a well ventilated ballroom.
From the swimming-pool or from the deck of a ship
Pleasures strike off humming, and skip
Over the tinsel surface: a Grief floats off

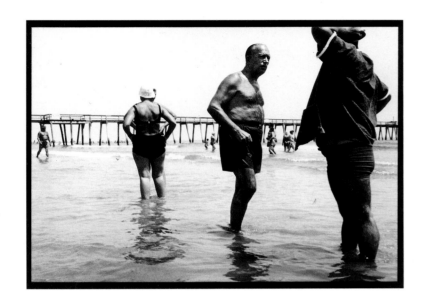 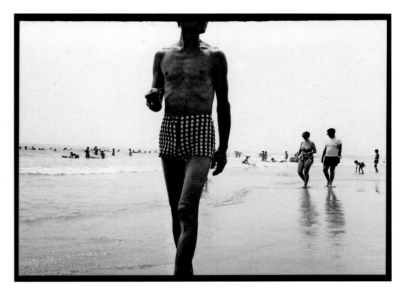

Spreading out thin like oil. And Love
Sets out determinedly in a straight line,
One of his burning ideas in mind,
Keeping his eyes on
The bright horizon,
But shatters immediately, suffers refraction,
And comes back in shoals of distraction.
Happy the people in the swimming-pool and on the yacht,
Happy the man in that airplane, likely as not—
And out there where the coral reef is a shelf
The water runs at it, leaps, throws itself
Lightly, lightly, whitening in the air:
An acre of cold white spray is there
Dancing happily by itself.

ELIZABETH BISHOP

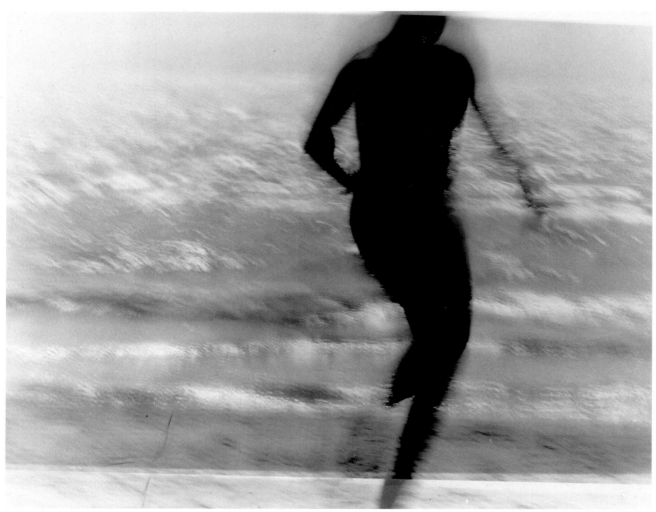

Dörte Eissfeldt, *Untitled*, 1986

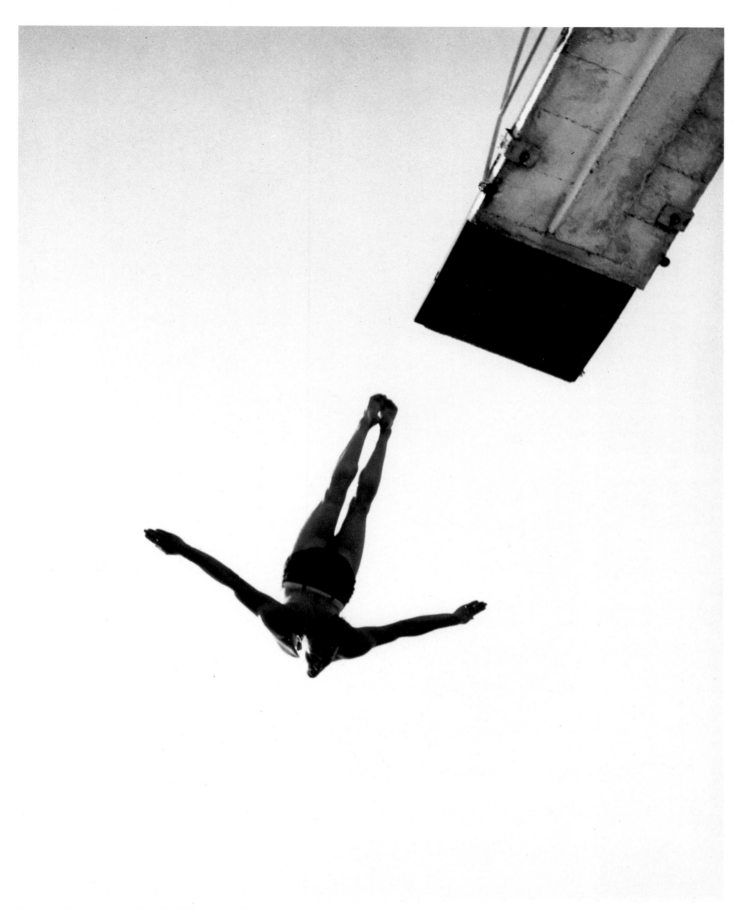

Fernand Fonssagrives, *Joie de L'Ardeche*, 1936

THE BEACH IN AUGUST

The day the fat woman
In the bright blue bathing suit
Walked into the water and died,
I thought about the human
Condition. Pieces of old fruit
Came in and were left by the tide.

What I thought about the human
Condition was this: old fruit
Comes in and is left, and dries
In the sun. Another fat woman
In a dull green bathing suit
Dives into the water and dies.
The pulmotors glisten. It is noon.

We dry and die in the sun
While the seascape arranges old fruit,
Coming in with the tide, glistening
At noon. A woman, moderately stout,
In a nondescript bathing suit,
Swims to a pier. A tall woman
Swims toward the sea. One thinks about the human
Condition. The tide goes in and goes out.

WELDON KEES

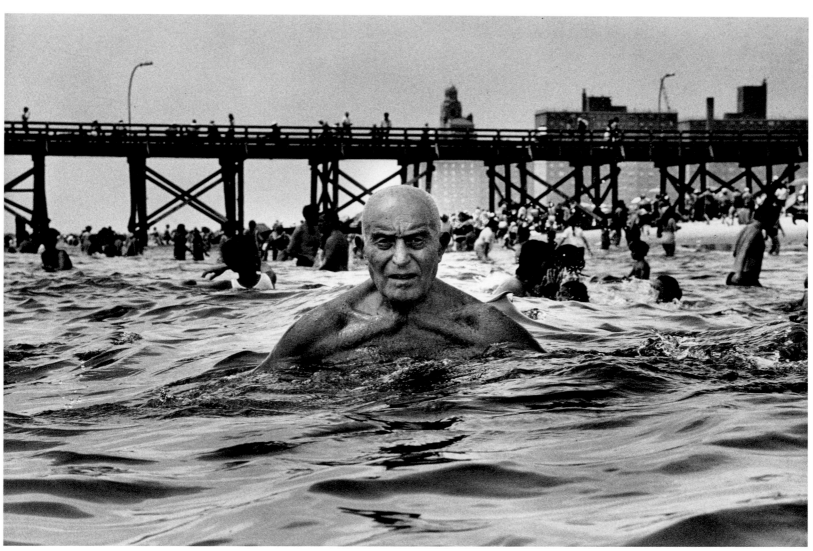

André Gelpke, *Coney Island*, New York, 1972

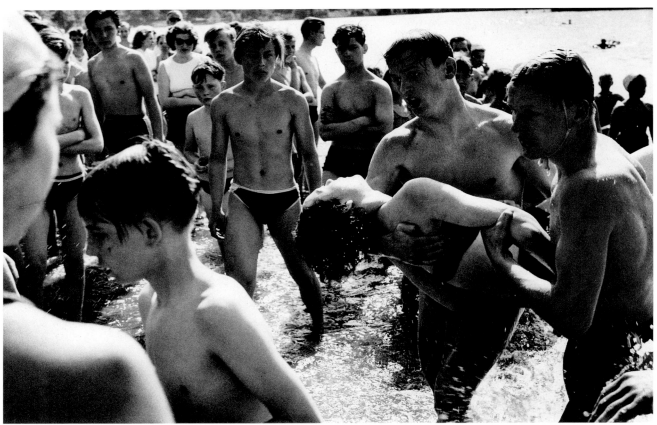

Will McBride, *Ein Ertrunkenes Madehen wird Gerborgen (A Drunken Girl Being Saved)*, Berlin, 1959

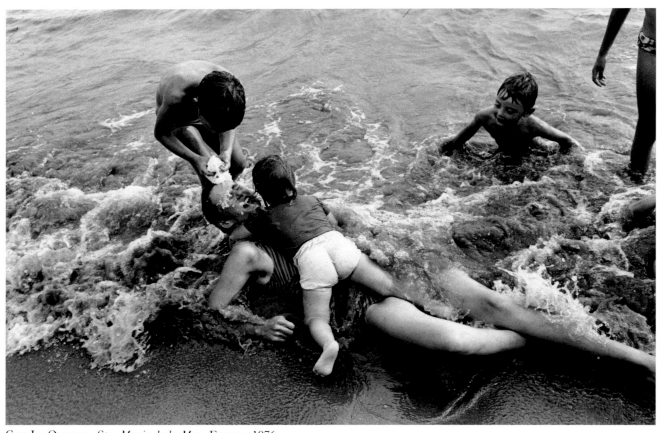

Guy Le Querrec, *Ste. Marie de la Mer*, France, 1976

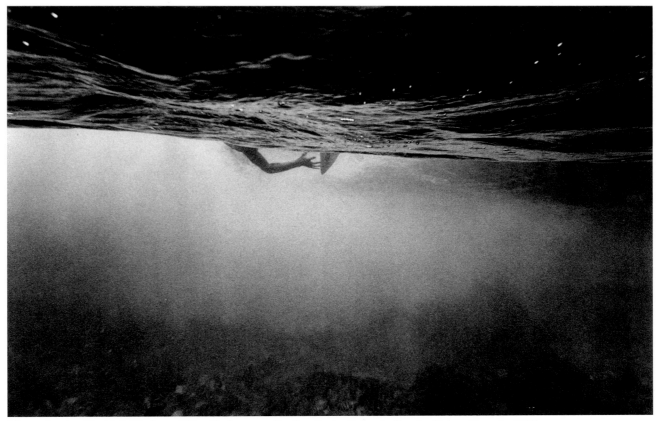

Wayne Levin, *Untitled #7*, from "The Underwater Surfing Series," Sandy Beach, Oahu, Hawaii, 1983

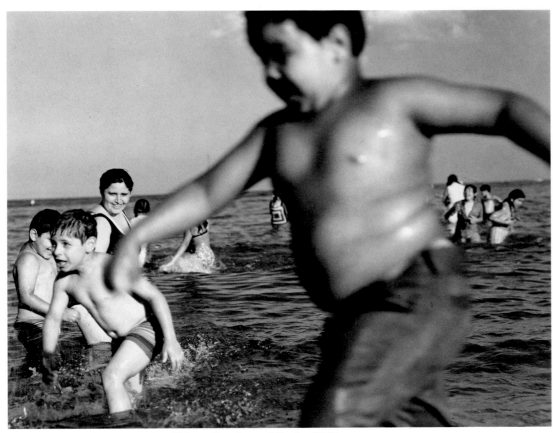

Barbara Crane, from the series *Chicago Beaches and Parks*, 1967

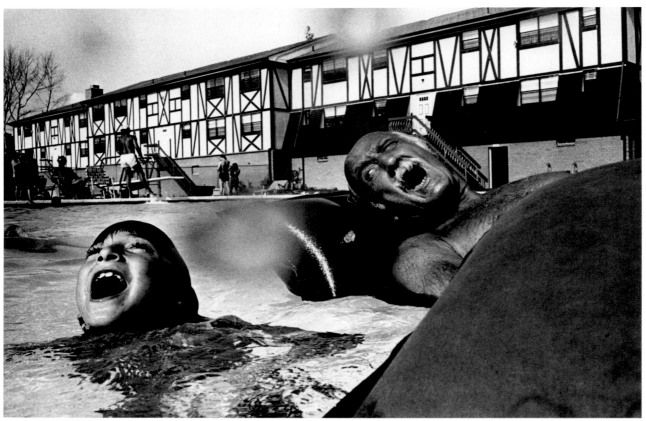

Sylvia Plachy, *Mishi and Grandpa*, 1980

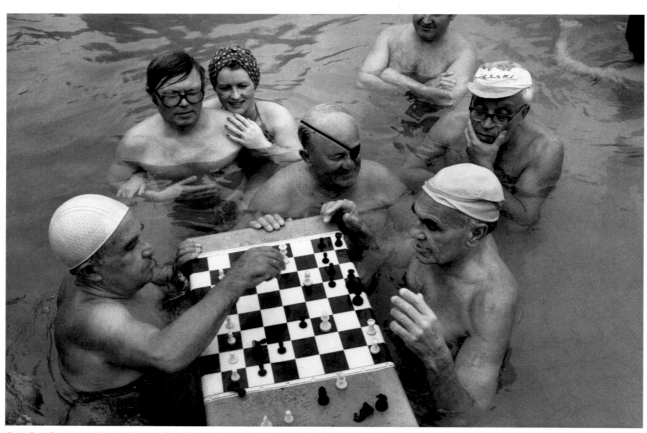

Guy Le Querrec, *Bainsthermes Szechnyi* (Thermal Baths), Budapest, 1980

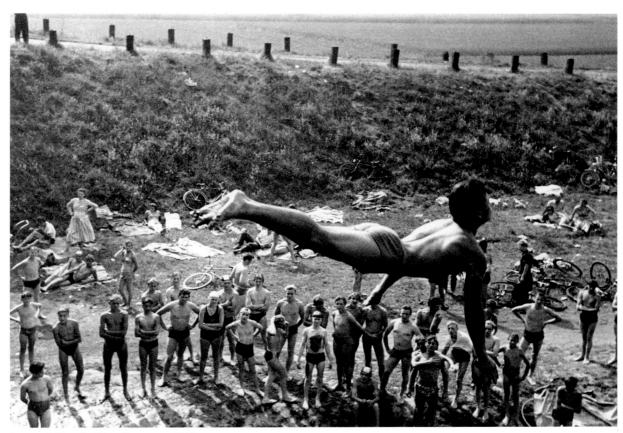

Leonard Freed, *West Germany*, 1965

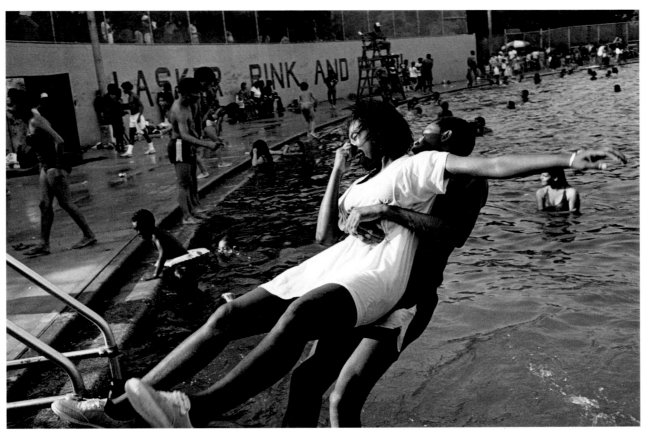

Sylvia Plachy, *Lasker Pool*, Harlem, New York City, 1982

"The three mermaids," Columbus relates, "raised their bodies above the surface of the water and, although they were not as beautiful as they appear in pictures, their round faces were definitely human."

LEVI-STRAUSS in *Tristes Tropiques*

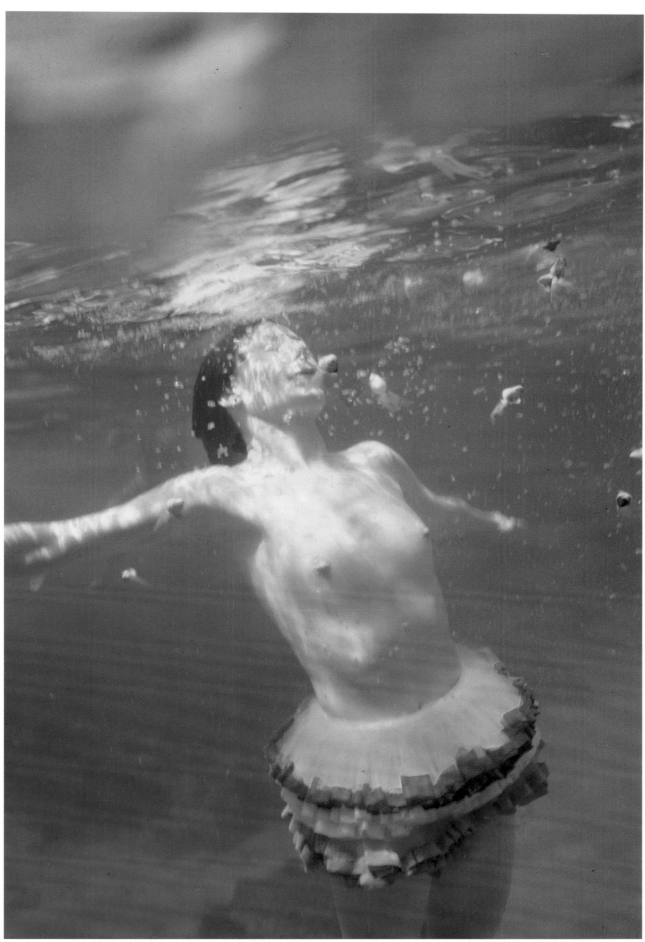

Laurie Simmons, from the series *Water Ballet*, 1981

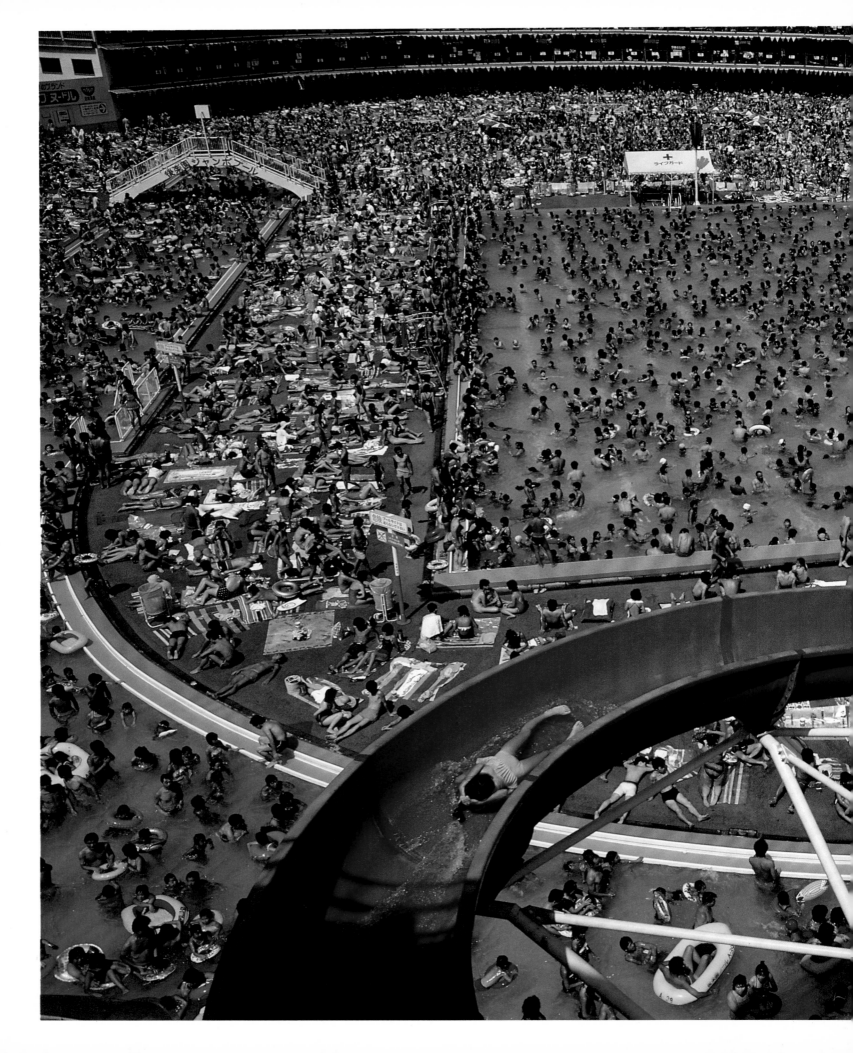

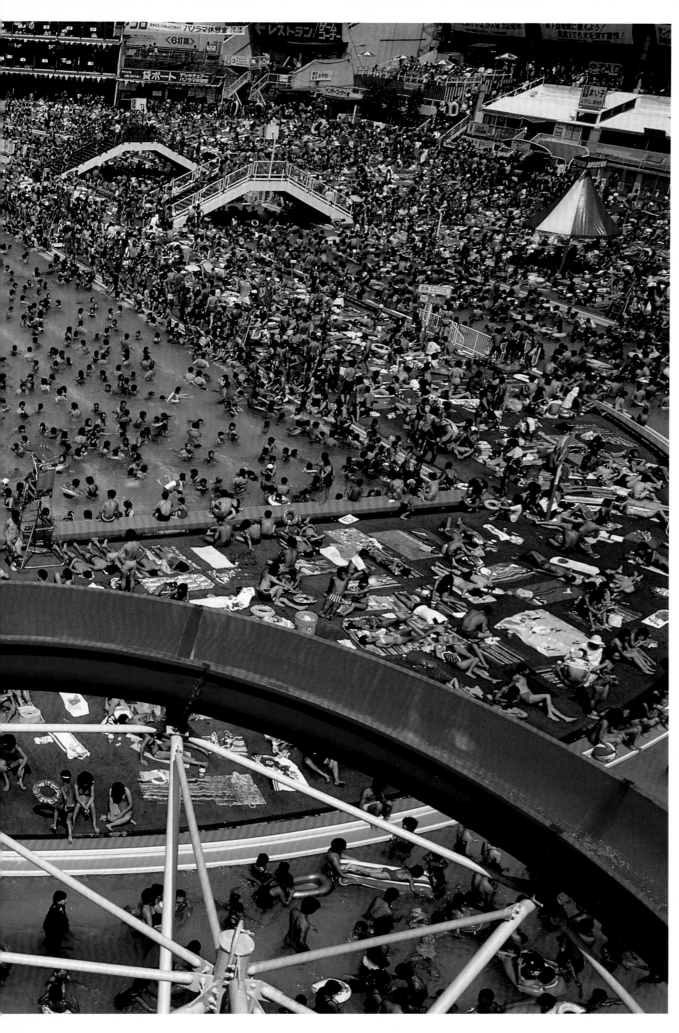

Tadanori Saito,
Korakuen Swimming Pool,
Tokyo, 1984

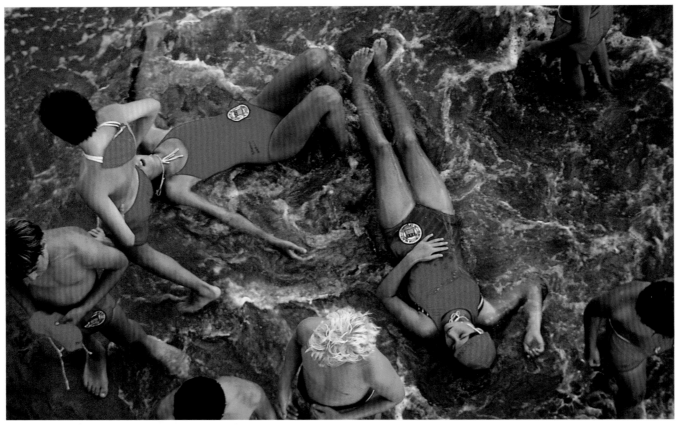

Roger Camp, *Floating Reds*, 1985

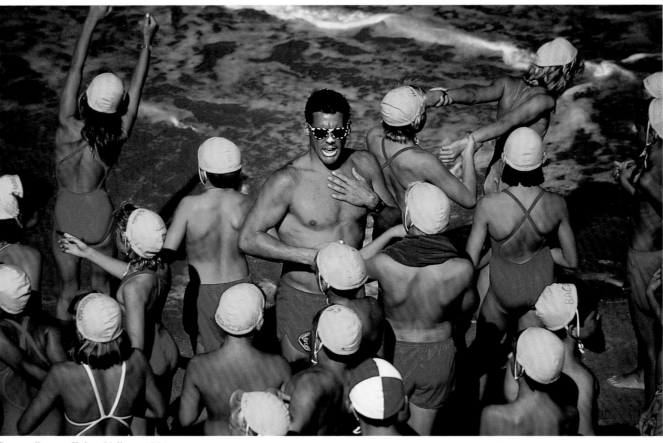

Roger Camp, *Zebra Yellow*, 1986

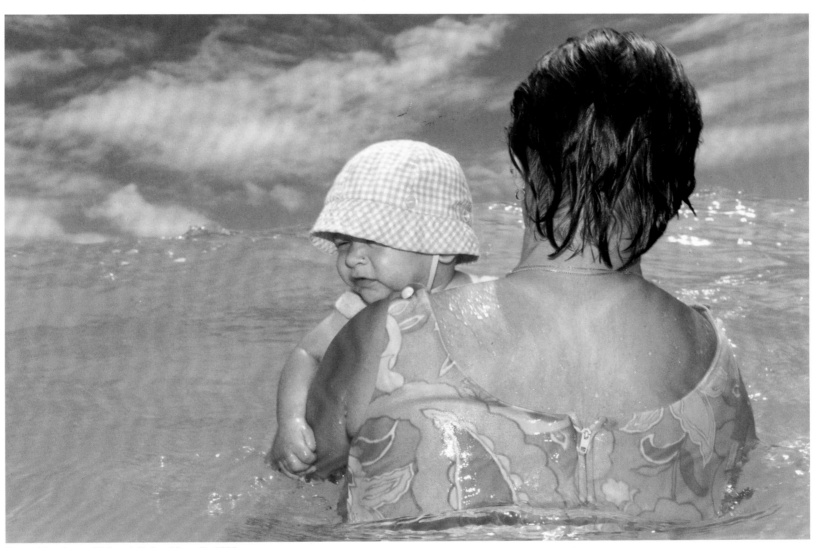

Tony Mendoza, *Girl and Baby*, Hawaii, 1982

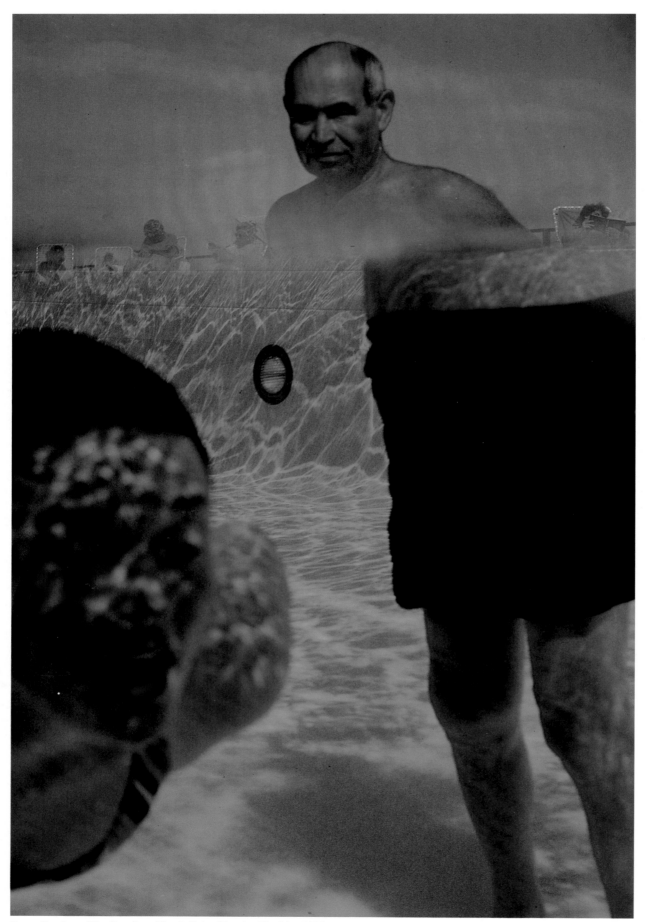

Jerry Gordon, *The Breakers Hotel*, Palm Beach, Florida, 1978

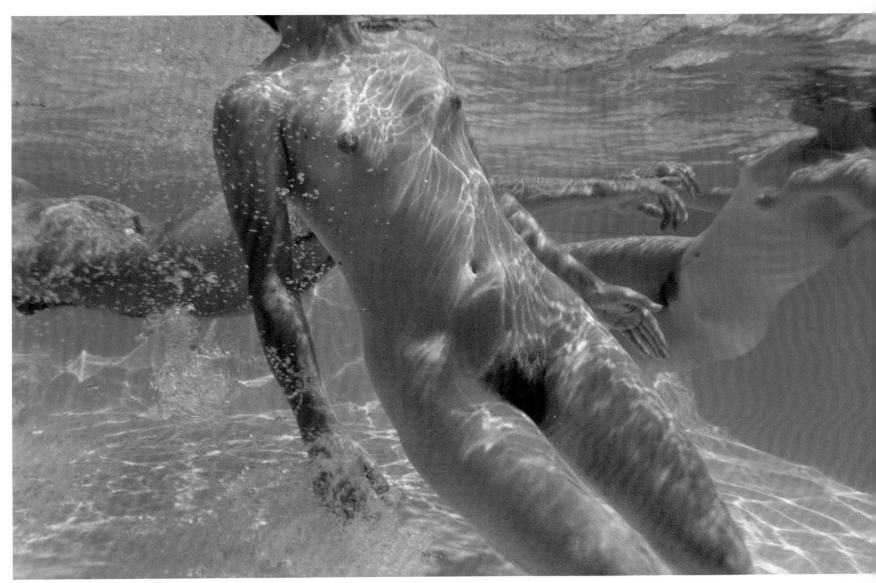

John B. Ganis, *Lakshmi*, 1983–1985

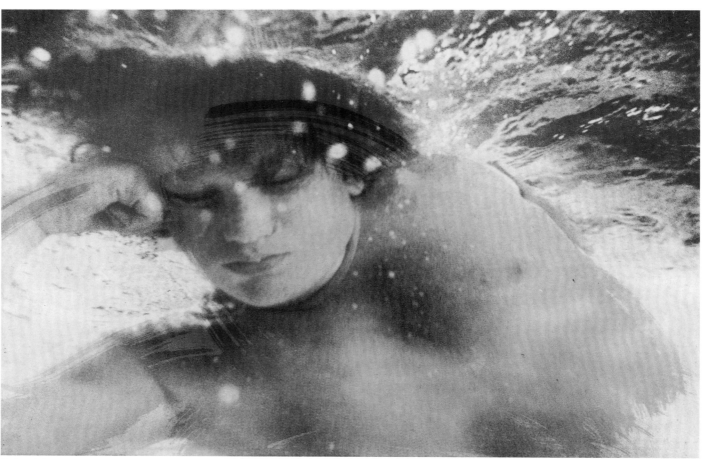

JoAnn Verburg, *Untitled*, 1975

X

After the rains left Macondo
in Garcia Marquez's One
Hundred Years of Solitude,
Aureliano Segundo asks the survivors
how they survived
the four years, eleven months
and two days of rain,
how they managed
to not go awash,
and all gave
the same answer: swimming.

Now here, a feeling
not unlike that of Verrocchio's Baptism
comes over me as I glide
through the water, my fingers
arced upward as in prayer,

my head bowed in a kind
of penance and forgetfulness.

So perhaps I too
will survive by swimming:
an amphibian moved first
by a stroke of genius, then
by a stroke of luck as I
weave through these waters,
a priest and a penitent
both at once, an expiator
of my own sins,
a quick eel, electric
in his own current.

MICHAEL BLUMENTHAL

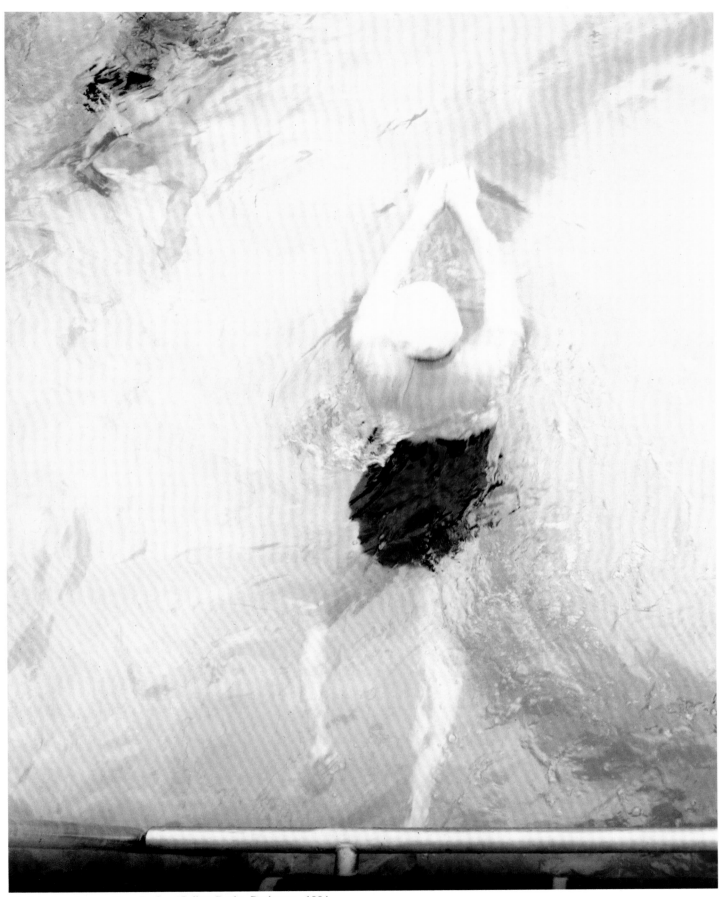

Christopher James, *Two Bathers/Gellert Baths*, Budapest, 1984

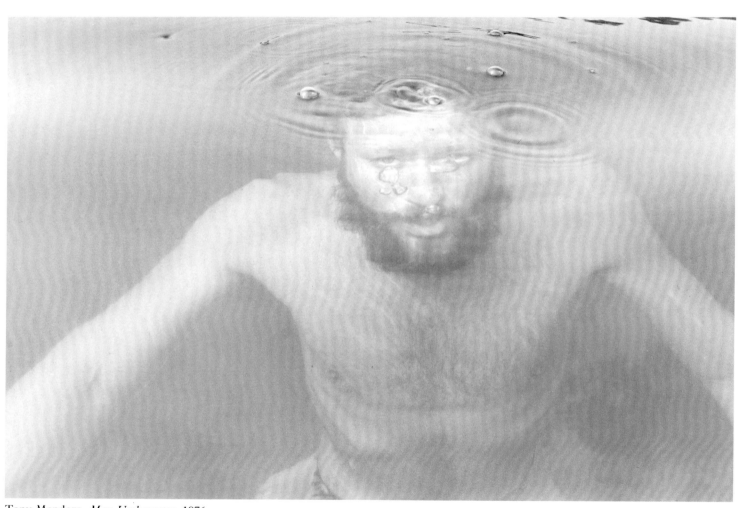

Tony Mendoza, *Man Underwater*, 1976

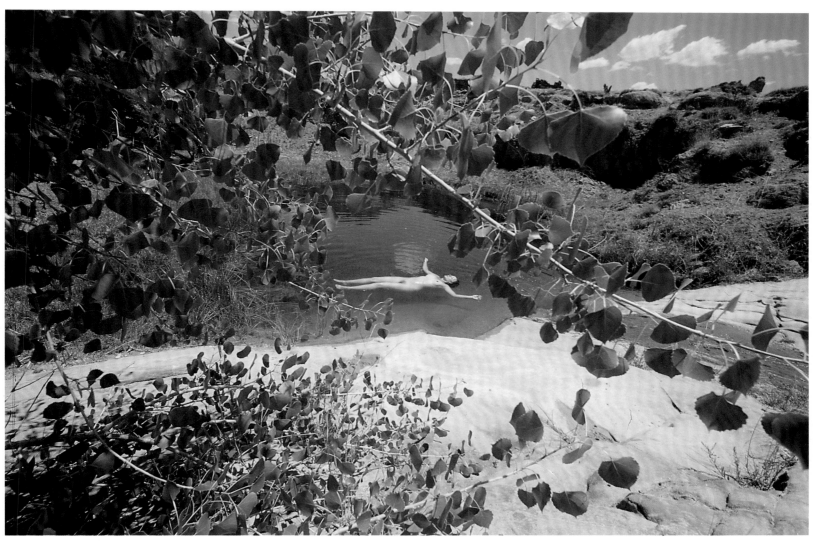

Robert D'Alessandro, *Sunlight Swimming*, Placidas, New Mexico, 1980

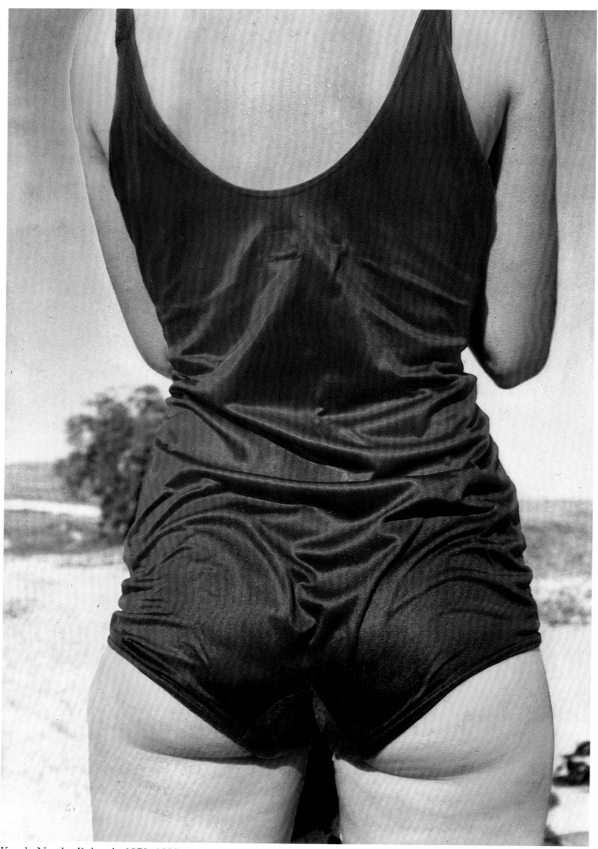

Kenda North, *Deborah*, 1979–1980

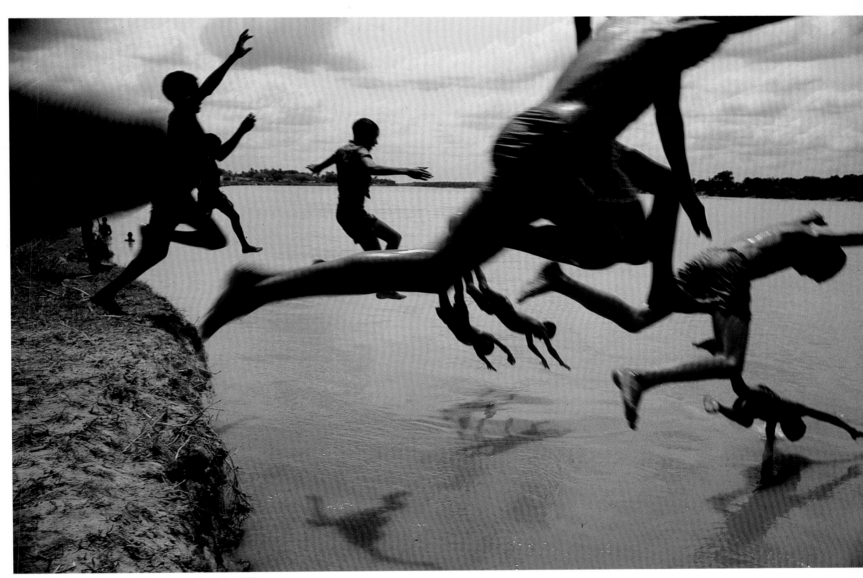

Bruno Barbey, *Manaus, Amazonas, Brazil*, 1973

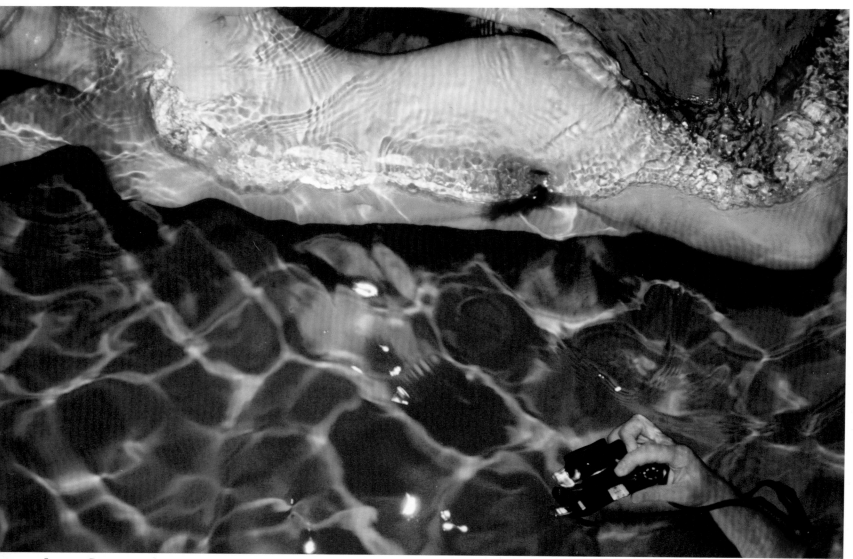

Suzanne Pastor, *Dollie with Camera*, Rochester at Night, 1980

Sheets of rain, salt lash, wind. The smell of sea and torn vegetation.

Wading across the deck to the spiral staircase, Melissa found it possible, in that blackness, to see the horizontal expanse of the cove—its churning, luminous foam— as a vertical wave about to engulf the house. This optical illusion she alternately entertained and dispelled. Her steps rang faintly on the steel stairs.

Her steps rang faintly on the steel stairs. She could hear the waves crashing in on the wave ramp. She put on the mask. . . . She dived.

It was as though the violent agitation of the surface were a membrane through which she had passed to a place of great familiarity and quiet. This is how you enter certain rooms, certain embraces, this is what a recollection is. She swam downward. . . .

TED MOONEY from *Easy Travel to Other Planets*

Lorie Novak, *False Starts*, 1986

"DOVER BEACH"—A NOTE TO THAT POEM

The wave withdrawing
Withers with seaward rustle of flimsy water
Sucking the sand down, dragging at empty shells.
The roil after it settling, too smooth, smothered . . .

After forty a man's a fool to wait in the
Sea's face for the full force and the roaring of
Surf to come over him: droves of careening water.
After forty the tug's out and the salt and the
Sea follow it: less sound and violence.
Nevertheless the ebb has its own beauty—
Shells sand and all and the whispering rustle.
There's earth in it then and the bubbles of foam gone.

Moreover—and this too has its lovely uses—
It's the outward wave that spills the inward forward
Tripping the proud piled mute virginal
Mountain of water in wallowing welter of light and
Sound enough—thunder for miles back. It's a fine and a
Wild smother to vanish in: pulling down—
Tripping with outward ebb the urgent inward.

Speaking alone for myself it's the steep hill and the
Toppling lift of the young men I am toward now,
Waiting for that as the wave for the next wave.
Let them go over us all I say with the thunder of
What's to be next in the world. It's we will be under it!

ARCHIBALD MACLEISH

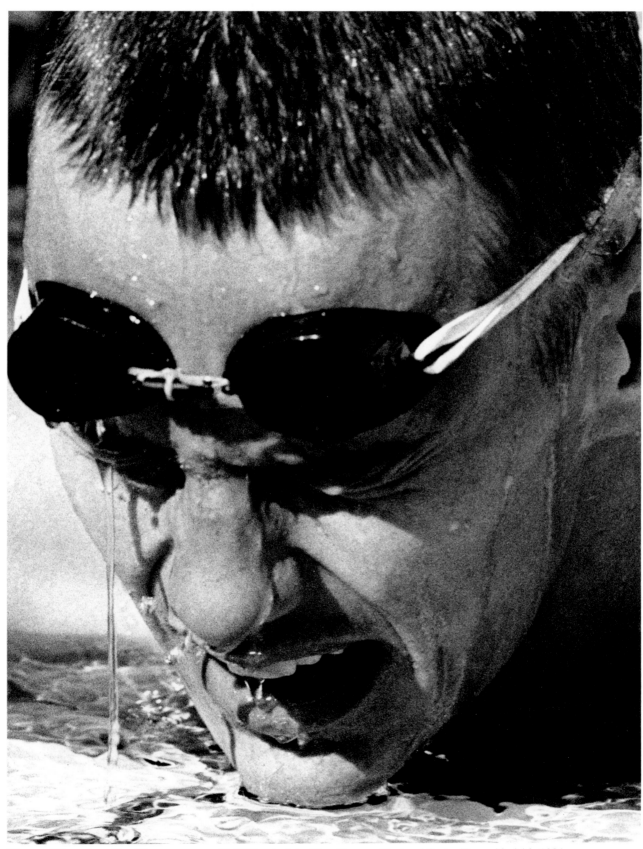

Thomas Wattenberg/dpa/Photoreporters, *Ralf Diegel of the West German National Swim Team*, Madrid, 1986

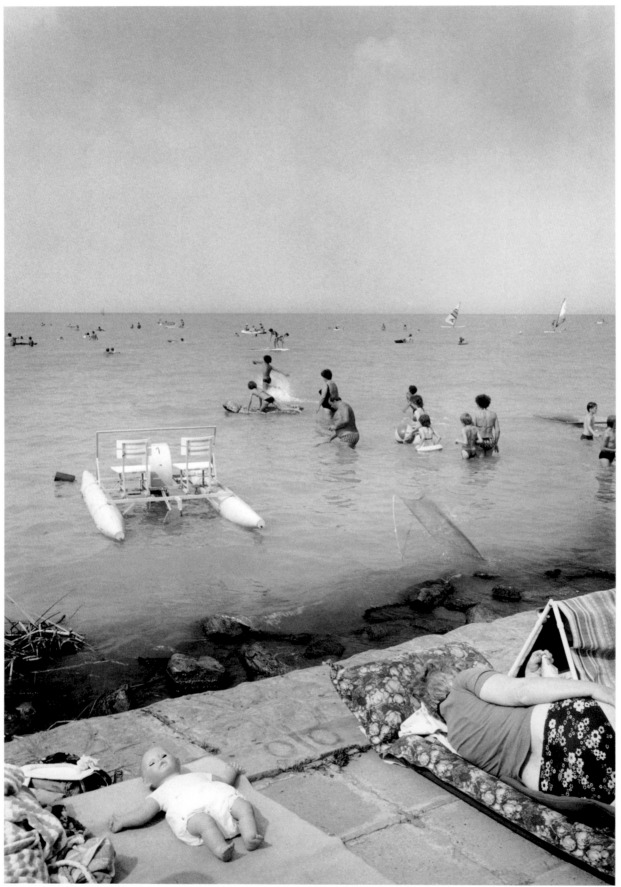

André Gelpke, *Plattensee*, Hungary, 1983

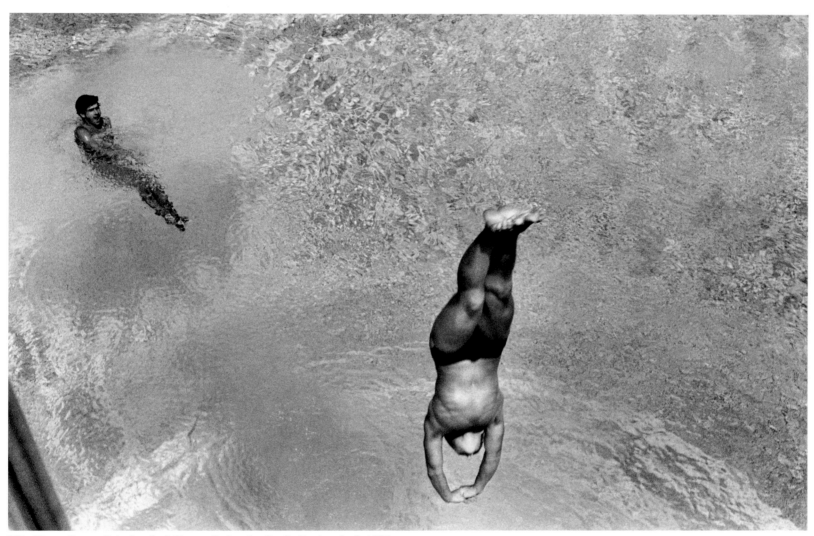

Ulla Haug, *Jump, Schwimmbad (Jump, Swimming Pool)*, Derkendorf, 1985

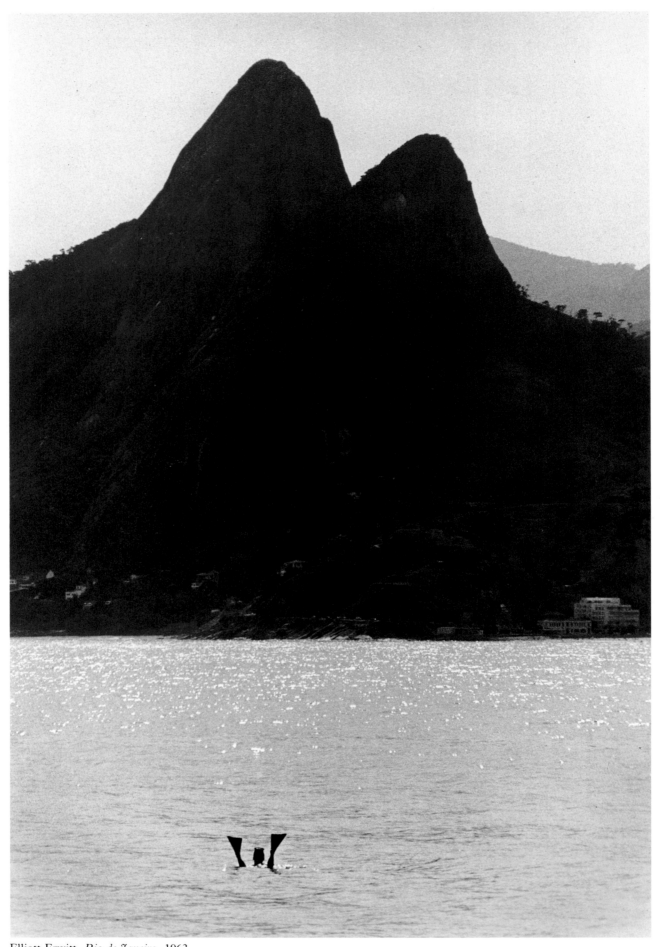

Elliott Erwitt, *Rio de Janeiro*, 1963

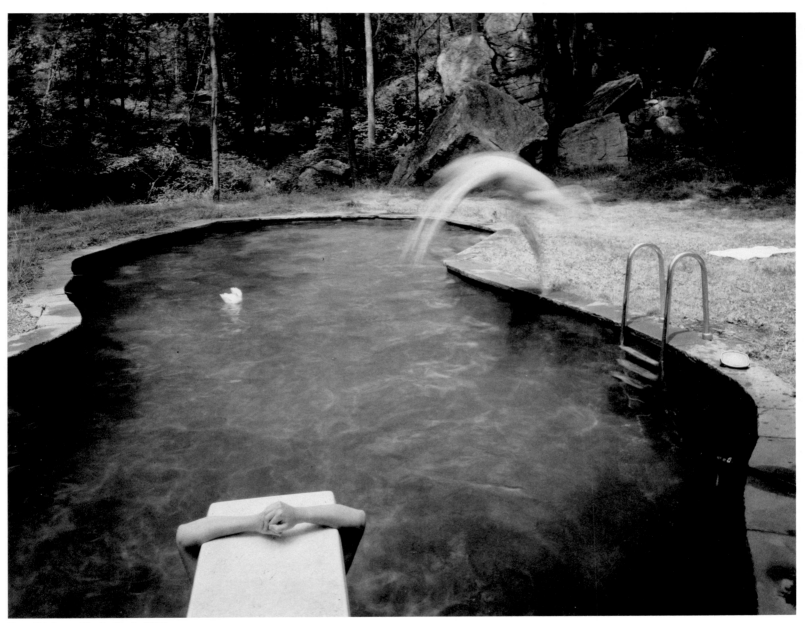

Curt Richter, *Earl's Pool*, 1982

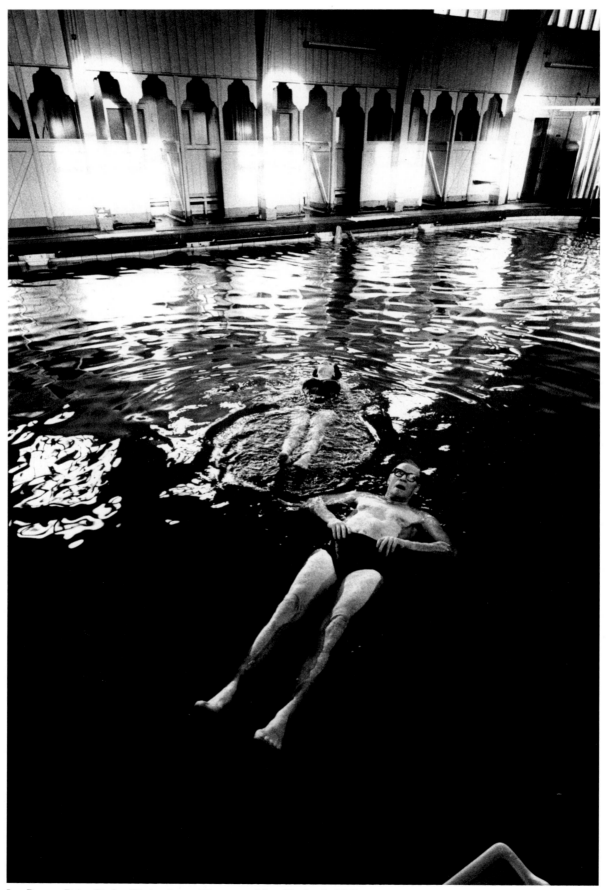

Ian Berry, *Brine Baths*, Cheltenham, Gloucestershire, England, 1969

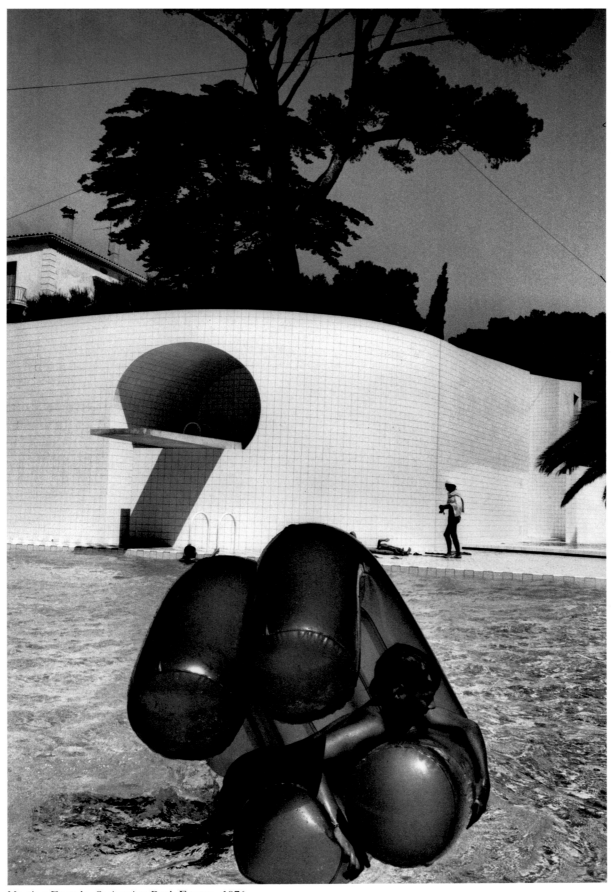

Martine Franck, *Swimming Pool*, France, 1976

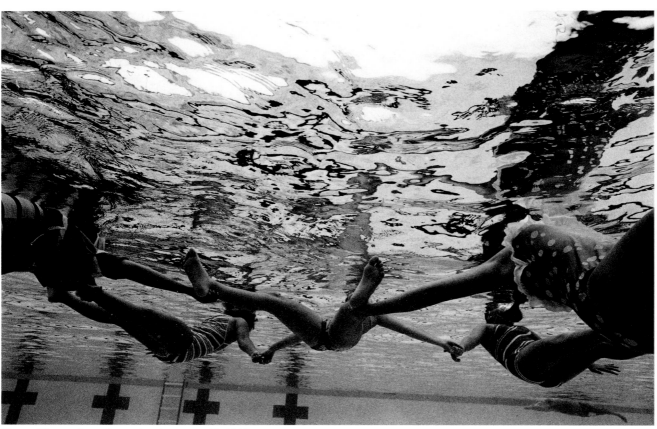

Karen Glaser, from the series *Aquanaut II*, 1987

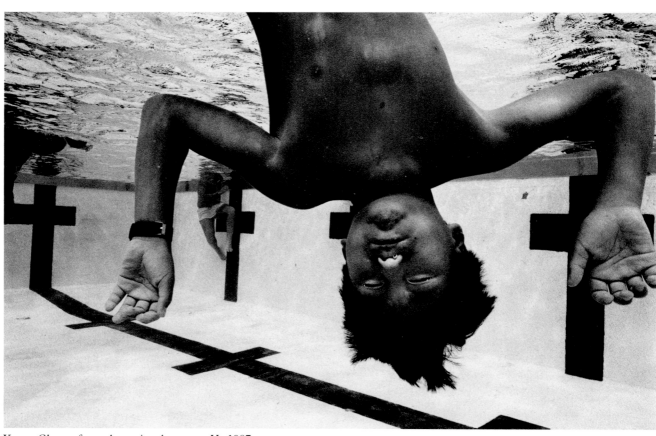

Karen Glaser, from the series *Aquanuat II*, 1987

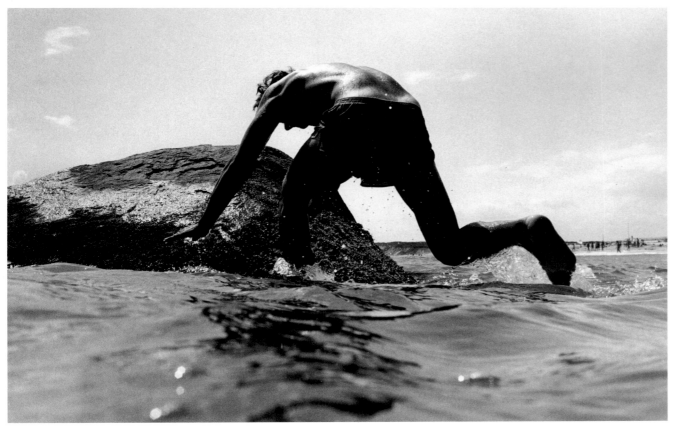

Larry Fink, *Martha's Vineyard*, 1984

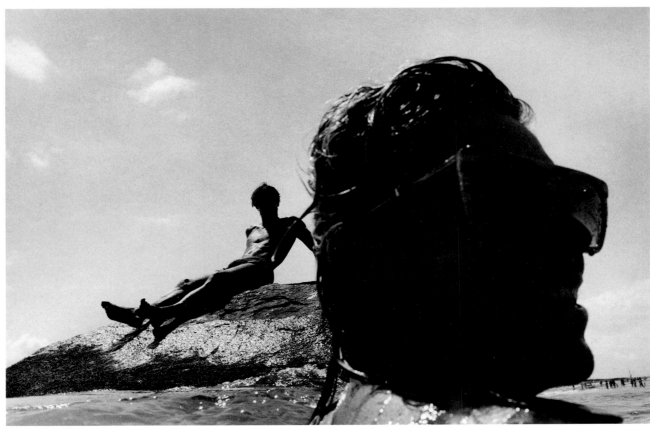

Larry Fink, *Martha's Vineyard*, 1984

SWIMMERS: HUMAN FIGURES IN AN AQUEOUS ENVIRONMENT
HANS CHRISTIAN ADAM

"To the Beach!" The cry brings back memories of bygone vacation days at the shore and led to a pastime which promised—first and foremost—pleasure. Swimming is conceived of as a happy event, one which stands out from the commonplace of everyday life, implying leisure time and vacation. When one is no longer conscious of sand between the toes, the next small step into the deep means the conquest of an element for which man was not, finally, designed. A sense of triumph is mediated. The contact with water forces a sense of one's own body—the initial coldness, rhythm, breathing. The freedom of three-dimensional movement is experienced and the primal dream of man—flight—comes true.

But alongside this joy of uninhibited movement is the ever-present glimmer of fear before unpredictable nature: the fear of drowning, of being drawn into the gloom of the unknown.

The first photograph which establishes a connection between the human being and water shows, most peculiarly, a person drowned in a bathtub. French finance officer, inventor, and amateur photographer Hippolyte Bayard felt he had been unjustly treated in the proportioning of government benefice resulting from the invention of photography, and, in October 1840, staged this shocking self-portrait. An equally "invented" farewell letter accompanying this photograph explained his grievance in a bitter protest.

But it was the well-known French photographer Henri Le Secq who, for the first time, succeeded in photographing the human body in water. In one of the

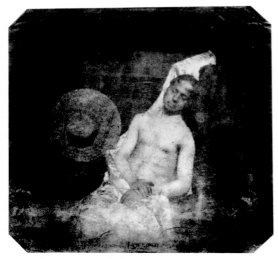

Hippolyte Bayard, _Self Portrait as a Drowned Man_, 1840.

Henri Le Secq, _Bain Publique_. Paris (?), c. 1853–1854.

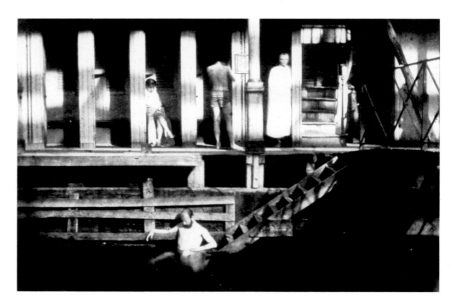

Seine River bathing establishments in Paris, he tested the patience of his male model, who stood motionless and half submerged for the time (then as long as seven minutes) required by the camera. Other bathers were posed in the doorways of their changing cabins; nothing was left to chance. Judging by the strong, almost vertical shadows, the photographs were taken on a sunny summer afternoon. The year was 1853 or 1854.

Perhaps it was those boatlike bathing structures anchored along the river whose box-shaped interiors were observed by Honoré Daumier, pencil in hand,

as he amused himself with subtle satire of his contemporaries. His highly acclaimed album *Les Baigneurs (The Bathers)* received this review when it appeared in 1845: "Leafing through this album, one can observe all manner of establishments for the sport of swimming, from the proletarian pool for 10 centimes to that lined with carpets. . . . Everything is seen at its most amusing, for the album is filled with grotesque physiognomies, droll scenes, and the full repertory of adversities that could befall the unhappy bather. We recommend it as a deterrent to the passion to which Leander and Byron were once subject."

Leander's remarkable feat, according to a sage of antiquity, was to swim each night across the Hellespont Straits between Europe and Asia Minor (the present-day Dardanelles), to reach his beloved Hero, who guided him from Abydos with a lantern she would light for him; until, one night, the lamp went out prematurely, and Leander went to his watery grave. English poet George Gordon Byron repeated this classic swim on May 3, 1810, in an unremarkable (by today's standards) seventy minutes. His aquatic triumph attracted considerable notice at the time, and contributed to the popularization of swimming in the nineteenth century.

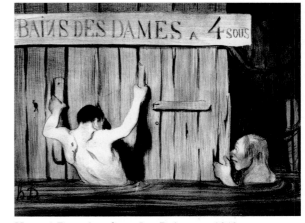

Honoré Daumier, from *Les Baigneurs*, 1842.

The scenes caricatured by Daumier could not be registered photographically to the same effect. Moreover, the public's demands upon photography at that time were of a different nature. Their interest was not in critical satire, but in the detailed representation of a situation, where the spontaneity of the moment was less important than its "universal" validity. They valued sharp-focus images made with a horizontally-aligned camera and thought that the stiff poses of human subjects appearing in front of the wooden apparatus were called for. Such poses were doubly necessary due to the complicated technique involved: the posing studio client stared for a small eternity at a predetermined point on the atelier wall, secured by props and supports to prevent any uncalled-for freedom of movement, surrounded by the status symbols of nobility or the bourgeoisie. What would be more unimaginable than to be photographed in classless nakedness, in water? Considering the standard of the day, Le Secq's photograph is especially singular; for here, a photographer operated contrary to the accepted world of imagery, for the pure pleasure of experimentation, for the play of light and shadow on a scene.

The invention of photography occurred in an era when bathing resorts blossomed everywhere. The new resorts provided a fund of enormous profit to commercial photographers. The established London portrait studios, such as that of John Mayall, opened branches in the fashionable seaside resorts like Brighton, not to record beach life, but to attract clients by offering representational portraits. The gilt-printed atelier stamp with particulars of an illustrious address underneath one's likeness signaled that the sitter belonged to the privileged class—who could afford to take vacations.

In all its conventions, the portrait was a public image, but affordable only by the few. Prints were expensive enough in the first decades of photography so that not more than one-tenth of the population could even afford to have a portrait taken. This was true at least in Europe; greater competition in the United States lowered prices and resulted in a higher percentage of portraiture there. Private photography comprised an even broader, unconsidered presence in the hands of a few amateurs, whose motives and technique differed little from those of their professional colleagues, for they came out of the same wealthy circles as the clients of the ateliers. Most of the portrait photographers—at least until the introduction of the dry plate technique after 1880—did not even con-

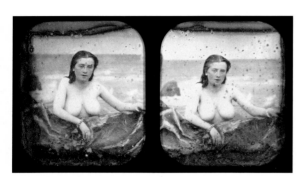

Anonymous, *Model in studio with artificial rocks and painted seascape background*, c. 1855.

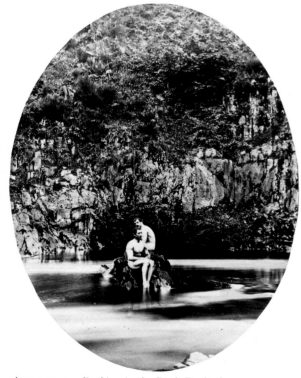

Anonymous, *Bathing in the Pool*, Poolaphuca, Ireland, 1861.

template hauling their voluminous camera and equipment (not to mention an entire darkroom!) to the beach.

Because of the technical and financial expenditures involved, photographs of swimmers and bathers in a natural setting before 1880-1890 are rare. By contrast, it was easier to arrange bathing scenes in the photographer's studio. Fake boats and painted backgrounds took care of the atmosphere called for, and hand-coloring or the choice of a stereo camera intensified the illusion of reality. Already by 1855, for example, a daguerrotype, probably made in Paris, depicted a bare-breasted model appearing behind papier-mâché rocks in a swim scene that provided a legitimization for nudity.

One of the numerous private albums of Queen Victoria herself, that paragon of virtue for the Western world, reveals an anonymous study of two naked men, their feet in water, sitting on a rocky island. Since the secluded place in the greenery of nature was called Poolaphuca in Ireland, and the remainder of the album depicts the life of soldiers in Kildare, the two men were probably members of the military. Around 1860, one bathed in the nude when privacy was available, women less than men, and as a rule, cameras were not present. This photograph is thus a rare document of fairly common, if not quotidian, mores of the period.

Photojournalism as it is understood today, did not exist in the nineteenth century, chiefly because the printed reproduction of a photographic original was not technically possible until the 1890s. Photographs of events served largely as visual references for woodcuts, which usually appeared in the illustrated press after a delay of several weeks. When long-distance swimmer Matthew Webb finally swam the English channel after his second attempt on August 25th, 1875, in twenty-one hours, he was met by dozens of reporters from the writer's guild—but not one photographer was to be found on the beach of Calais. Instead, a sketch completed after the victory appeared in the *London Illustrated News* as a romantic woodcut, showed the swimming Webb by moonlight, accepting a cup of coffee from the accompanying boat.

Granted there was a limited market for photography, which had to do with the expense of producing such large format, quality images. Occasionally such images were recorded by amateurs who were more numerous in England than elsewhere. In the land of this sport's birth, swimming competitions were held in rivers or in the sea, due to lack of pools and basins. What indoor baths did exist—in Liverpool (built in 1840) or in Berlin (1855)—remained exceptional places, having little influence on the public's swimming habits.

For the most part, the largest number of photographs of people in or near water originating in the nineteenth century were made in the realm of travel photography. Towards the end of the century such images proliferated with the advent of mass-produced stereo cards and the triumphant advance of picture postcards. In the preceding decades, travel photography had been closely tied to the colonial interest of industrialized countries, whose governments frequently financed expeditions and trade missions in distant lands. The extension of roadways and modernization of the means of travel contributed to the popular interest in this leisure activity. A demand for pictorial souvenirs grew, so did the founding of the photographic publishing houses such as James Valentine and George Washington Wilson in Scotland, the Alinari Brothers and Georgio Sommer in Italy, Lambert in Singapore, and Taber in San Francisco. En route between Liverpool and Calcutta, between Boston and Yokohama, one could purchase photographs at local ateliers, or order them, by mail upon return, bound into

huge albums. In looking through these turn of the century memoirs, one finds the greatest quantity of nineteenth-century pictures of people in water.

Such photographs often served no purpose other than to enliven more traditional subjects or to accentuate exotic landscapes; only occasionally did they inform about the customs of alien peoples. Outside European cultural circles, an entirely different attitude to swimming prevailed. It was viewed either as a useful skill or as one in the service of a profession such as sponge or pearl diving. In countries like India, bathing continues to have a religious significance, as swimmers in the Ganges River ritually cleanse, not only the body, but the soul. But for Western photographers and business firms, the *mise en scène* was of greater importance than a realistic representation of life.

It was only after 1880 that growing numbers of amateur photographers began to create a new world of images, where real impressions rather than artificial scenarios were pictured. The increase in leisure-time activities resulted from changes in working conditions and accelerated life in big cities. Kodak began the development of film on an industrial level, little by little augmenting the number of amateur photographers, whose use of the medium required little knowledge of technique. Making photographs became a leisure-time hobby and leisure became the favorite theme of amateurs. Snapshots of family life, in particular, gained popularity and validity. As a hobby for amateurs, photography was advanced more by the dry plate and roll film than by the first "box" cameras. Though still on the expensive side, cameras were soon possessed by many enthusiasts of better means.

Hobbyists were not the only group to take up the camera—artists began to recognize its applications and adopted photography in their work. Thomas Eakins, painter and professor of art, was one of the first to use the camera to trans-

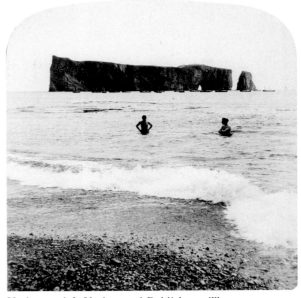

Underwood & Underwood Publishers, *The Famous Percé-Rocks, Percé, Quebec*, Canada, c. 1902.

Thomas Eakins, *Male Nudes, Eakins' Students at a Swimming Hole*, c. 1883.

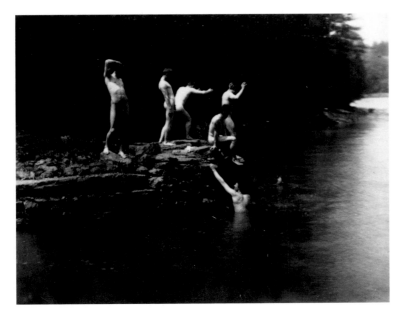

form natural scenes into paintings. Around 1883 he posed students on the edge of a watering hole, sent others into the pool, and then pressed his shutter. He also used the camera for a multitude of experiments, including his important series on movement.

Through technical advances, such as the focal-plane shutter developed in 1888, which had already made possible exposures of 1/1000 of a second, pho-

tography conquered new territory, including the taking of pictures underwater. Already, in 1856, Thompson and Kenyon, an English engineer and amateur photographer pair, attempted a subaquarean photograph, with, however, most unsatisfactory results. Around 1893 Frenchman Louis Boutan, professor at the zoological research center of Banyuls-sur-Mer, succeeded for the first time in taking pictures of people underwater, some even while in motion. A diver carried a magnesium torch below the surface which distributed a glistening

Louis Boutan, *Diver with Magnesium Torch*, c. 1893.

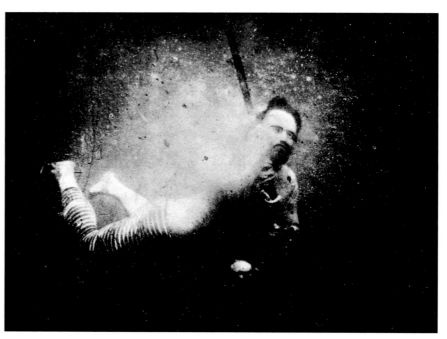

light, bright enough for an instant's exposure by a camera installed in an aquarium-like structure. The resulting images nevertheless showed some rough imperfections: the diver's face was totally obliterated by the brilliance of the light and had to be considerably retouched. Boutan also photographed deep-sea divers on the sea floor, lit with a magnesium lamp in a waterproof glass casing, whose drawback was its tendency to explode from the heat generated.

If the sensational was already a characteristic of illustrations in newspapers and magazines, topicality became another expectation of the readers by the late 1890s. More and more publications turned to printing autotypes from screens processed from photographs. After the turn of the century, the first professional photographers began to specialize in press photography, often while operating portrait studios on the side.

The step into the new century meant a new phase in the application of photography. It spurred new photographic professions, broader potential for the photograph's application, a clearer division between amateurs and professionals, as well as several technical innovations. Under these conditions, as well as the swelling cult of nudism at the beginning of the twentieth century (especially in central Europe), people in or near water found themselves more frequently in front of the camera. The many products—regarded today as kitsch—of the photographic publishers were occasionally photographed in the outdoors and largely sold as postcard motifs. Published in editions of more than 100,000, the images wrested their success entirely from the nakedness of the models. The same was true for the mass production of machine-made reproductions in the

form of postcards, whose "bather" displayed all the features of the pin-up girl. This sort of image was mostly produced in urban studios, but belonged to the repertory of beach and ocean resort photographers as well.

Bathing beaches in the United States differed from the European in their sociocultural value, but photographers on both sides of the Atlantic quickly discovered the money to be made from the palette of motifs offered by the bathing and amusement parks, beach promenades, and hotel architecture. Typical beach constellations were staged as genre scenes or as photomontages. In competition with the increasing numbers of snapshooters, photographers offered mementoes to all those unfortunate enough not yet to possess a camera.

On the beach or in the water, subjects were posed for group shots which assured additional income: a single negative presumed the sale of numerous prints. Many a beach photographer made use of human vanity, photographing the man as chicken in the basket of a group of females. The printed text of one such postcard, meant for individual use, depicting a man with four women, ran: "Have too much to do to write." Quantities of interchangeable beach girls in a variety of unidentified scenes were produced by the larger postcard publishing companies, and simply carry the printed message: "Greetings from . . ." The location of the bathing resort could be filled in by the visitor.

Around the turn of the century the "family resort" was introduced and visitors began to complain that the beach was now a place for voyeurism. Increasing numbers of male photo amateurs used their camera as pretext for approaching the women in the irresistible optical temptation of their zebra-striped swimsuits. The event of the "bathing machines," as England dubbed the cabins which

F.W. Guerin, *Untitled,* c. 1902.

Anonymous, from an article entitled *A French Girl at the Seaside,* 1909.

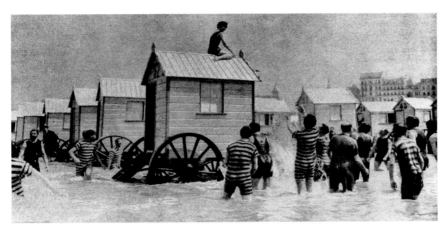

rolled out into the water, provided especially gratifying opportunities. Images from the period depict an entire gang of photographers, all standing to their knees in water, awaiting some young beauty to emerge from the door of this vehicle. At times, officials felt called upon to interfere. In 1893, for example, to the dismay of the *Photographische Mitteilungen* in Berlin, a disapproving Belgian court in Bruges announced the prohibition of cameras on the popular bathing beach of Oostende.

One of the private portraitists of the time was a young Frenchman named Jacques-Henri Lartigue, a kind of *wunderkind* of photography who captured all variety of images from the world of automobiles, airplanes and water sport. Along with his fascination with decisive changes in technology before the first World War, Lartigue was interested in the trivial pleasures of everyday life. Frank and absurdly charming snapshots testify to his unique camera vision.

Lartigue regarded himself as a snapshooter who seized the exciting or otherwise specially worthy moments of his life with photography; his images were not meant for public appraisal, but were destined to be remembrances preserved in albums. The singularity of his vision lay in the fact that he handled his camera with professionalism and with candidly scientific, graceful humor. The offspring of well-to-do-parents, Lartigue was of independent means and could afford over a long period of time to indulge his pleasure in photography. He first published his pictures at a very late age. Although his work did not influence the historical development of the medium, today his contribution to the documentation of an epoch is warmly appreciated.

In contrast to the images of Lartigue, one photograph which made a lasting impact on swimmer photographers is an image made in 1917 by André Kertész. The first modern swimmer image, it became a classic, the elements and composition of which still wield a power for the contemporary eye. It is difficult to imagine that at the time of its creation a world war was taking place. Far from a personal snapshot, Kertész's image was a meticulously composed fore-

André Kertész, *Esztergom, Hungary,* 1917.

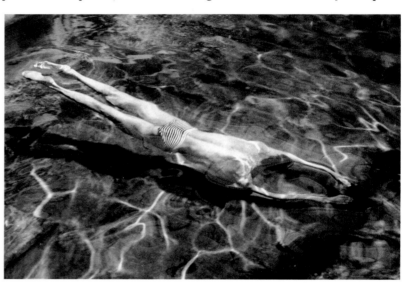

David Hockney, *John St. Clair Swimming,* 1972.

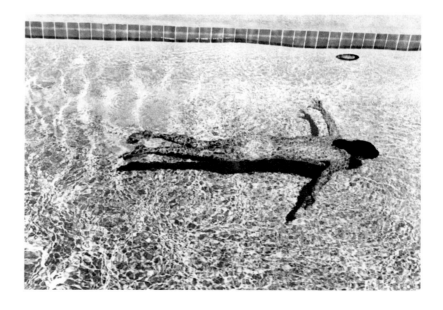

runner of the style of the twenties. The viewpoint from above, reduction of the picture subject to essential visual elements, the breakthrough diagonal structuring, the scattering of light through the water and the delineation of its reflections express a novel, dynamic, optically objective and visually mystifying experience. As a result of this photograph, a number of photographers were said to have reoriented their work, taking up the subject of the swimmer with artistic intention—often only to alter one or more variables used by Kertész. Years later David Hockney added color to essentially the same subject, but his photograph, reproduced here as black and white, makes its heritage clear.

Kertész also succeeded (and was perhaps the first to do so) in giving pictorial expression to the ambivalent sentiments of an individual in water. In this photograph one absolutely feels the caressing flow of water around the body and the simultaneously threatening nature of shadow patterns from the deep.

It took many years for swimming to be accepted as an appropriate subject for photography. One photojournalist later caught Mussolini in the water—and Hitler was aghast when the photograph of his swimming colleague came to light: "I hate all these people who suddenly become sporty. . . . Even the Duce, this is really ridiculous—he can't even swim! If the people should ask me: why don't you do any sports? Well, because I know I would in any case make a ridiculous figure! . . . " Bismarck answered the request that he take a swim: "I do believe I could, but I think it would not be correct, one would have expectations I would not fulfill. The Duce shouldn't do it either—he should be leading his country!"

It was customary to leave swimming photographs to reporters in the field of sports competition. Pictures of competitive swimmers were taken in pools with standard-length lanes. The brief exposure shots captured their subjects performing the Australian crawl, their faces grimacing with effort shortly before the start, or else during the victory ceremony on the triple-tiered podium. These motifs are repeated even today: the three winners on their victory pedestal—whether at a local competition or the world championship—remain virtually interchangeable. Occasionally, the caption lifts someone out of anonymity; indeed, it alone announces the uniqueness of an event illustrated by a stereotyped image.

Among the subjects which have dominated the pages of newspapers and magazines during the uneventful haze of summertime are those of overflowing pools, filled with all sorts of curiosities, like the bathing suit that made the non-swimmer unsinkable, and the book to be read while awaiting the lifeguard. On a hot day, one enterprising journalist set a young woman with typewriter in the swimming hole, combining the sweat of work with a cooling flow of water. What about the female model who held the jaws of her pet alligator firmly closed, hoping all the while for the lizard's good behavior, or the small, illustrious societies who took their tea in the swimming pool? Similar scenes remain all but unchanged over time. The wonderful custom of drinking ice-cold refreshments at poolside, or of playing water-chess, has continued; our archives are full of such images.

Celebrities and politicians have always received special treatment by press and other photographers. Their images often contain messages—hidden and overt. Mao Tse Tung was once sent into the water with his contingent of guards after a long absence from public appearance, in order to quell speculation about a malady Mao was said to be suffering from. The photograph of this famous swim, ostensibly in the waters of the Yangtse River, was distributed to the

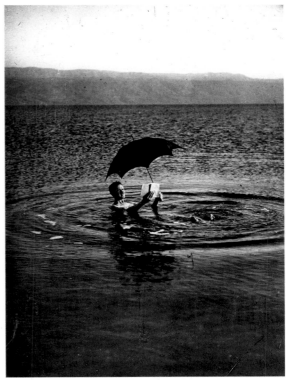

Erik G. Matson, *Floating on The Dead Sea.* Palestine, c. 1920.

world by the Chinese wire service. But what the editors received was of such poor quality that neither the identity of the swimmers nor that of the river could be established with any certainty. They had to rely entirely on the caption.

The twenties and early thirties were characterized by new impulses in the realm of imagery—"New Vision" and "New Objectivity," modern photojournalism—and also by a broadening of the applications and methods in the use of the medium. Cameras became smaller and more efficient, film more sensitive, snapshots increasingly successful. Books and illustrated papers appeared printed in gravure and demonstrated impressively high quality. All of these enriched the image of man in and around water. Well-known photographers from the Bauhaus or its followers, like Moholy-Nagy and Otto Umbehr (Umbo) and other promoters of new visual modes, like Edward Weston, Nathan Lerner and Henri Cartier-Bresson, contributed fascinating images dealing with the subject of water. Among these photographers Hungarian-born Martin Munkacsi worked extensively with the subject of swimming. In 1935 he reported for *Harper's Bazaar* on a diet farm in an essay entitled "Swim to Thin." For *Vogue*, Munkacsi photographed swimming fashions, often entering the water with his rather clumsy, heavy, large-format camera.

During this period fashion photography grew and began to take on the aura of film-star photographs. The star cult following upon the broadening film industry after World War I was advanced through photography, the press, picture

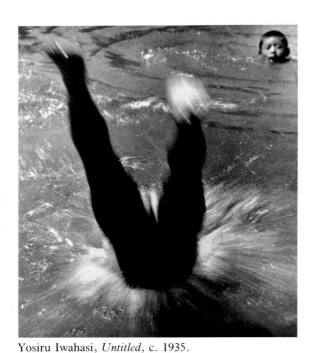

Yosiru Iwahasi, *Untitled*, c. 1935.

Anonymous, *Esther Williams and Friends, film still from Dangerous When Wet,* 1953.

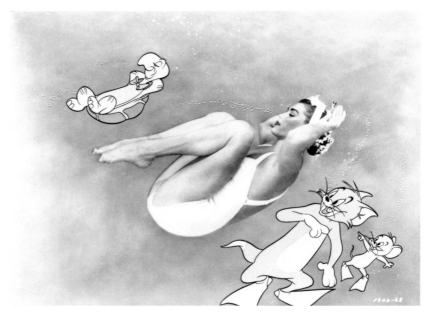

postcards, film stills and portraits of the stars in famous roles. Hollywood also drew famous watersport stars to its lair, some of them reaching international fame long after their original abilities had ceased to play a role. Johnny Weissmuller was the first to break the "sound barrier" by swimming the hundred-meter crawl in less than a minute. Five times Olympic gold medal winner, he set sixty-seven world records in the twenties. Afterward, Metro-Goldwyn-Mayer suggested he climb a tree and capture an escaped girl—and Tarzan was born. Another Olympic gold medalist, Esther Williams, after winning the 1932 Olympics in Los Angeles with the best time, became, over the next 20 years, Hollywood's "water nymph on call." Her stunts made it possible for her to appear with extraordinary partners, including cartoon characters Tom and Jerry.

At no point in its history has photography been so multifaceted as in the past two decades. In its contemporary treatment of swimming as a motif—technically and aesthetically—everything is possible. Many of the themes touched upon in the history of photography are being grasped anew, others reinterpreted, cited and, on occasion, transformed by new visual solutions. The arsenal of expression particular to photography, is being thoroughly explored, and often repeated: so many images recall or resemble—almost inescapably—previous images in their point of view. Monographs devoted exclusively to the beach, swimming and bathing proliferated in the last several years: including Harry Callahan's *Water's Edge* (1980), Jerry Gordon's *Swimmers*, (1982) or Franco Fontana's *Piscina* (1984).

Swimming as a photographic subject still offers an element of surprise. Neither in reality nor in a photograph does one expect to espy a swimmer like the remarkable vision Garry Winogrand photographed in 1964 in a tourist town

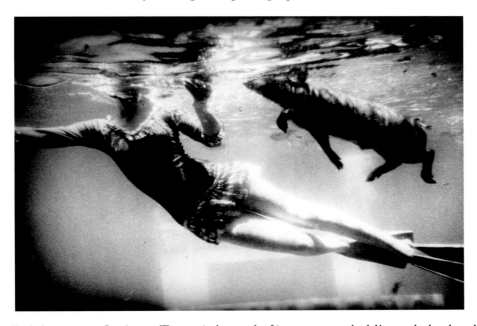

Garry Winogrand, *Untitled*
(Aquarena Springs, Texas), 1964.

called Aquarena Springs, Texas (where else?): a woman holding a baby bottle for a pig which drinks while swimming. The unexpected in a swimmer-image can also, in the tradition of Kertész, assume a more formal character which contributes to mystical explanation, as in Christopher James's photographs of the indoor pool of the old-fashioned Gellert Hotel in Budapest. To attract attention to their swimmer photographs, a growing number of young photographers apply unusual techniques (though no longer quite so unusual) such as cyanotype or hand-coloring. At times, they might use the physical dimensions of the printed swimmer motif to shock or impress. Through a combination of perfectly mastered handwork and progressive phototechnique, the huge print boasts a shiny, luminous surface—not in the colors of reality but in those supplied by Ciba, Kodak, Polaroid and others.

Over the years it is the photographs illustrating the joyful nature of swimming that prevail. We continue to be drawn to the pleasure of the human figure in water, on vacation or in the competition of sport captured in a pose or in a candid snapshot. Such images offer another dimension in the realm of human existence made accessible over time, along with the continuum of human vision and the culture of graphic images.

Translated from the German
by Suzanne E. Pastor

THE HARBOUR

The fishermen rowing homeward in the dusk
Do not consider the stillness through which they move,
So I, since feelings drown, should no more ask
For the safe twilight which your calm hands gave.
And the night, urger of old lies,
Winked at by stars that sentry the humped hills,
Should hear no secret faring-forth; time knows
That bitter and sly sea, and love raises walls.
Yet others who now watch my progress outward,
On a sea which is crueller than any word
Of love, may see in me the calm my passage makes,
Braving new water in an antique hoax;
And the secure from thinking may climb safe to liners
Hearing small rumours of paddlers drowned near stars.

DEREK WALCOTT

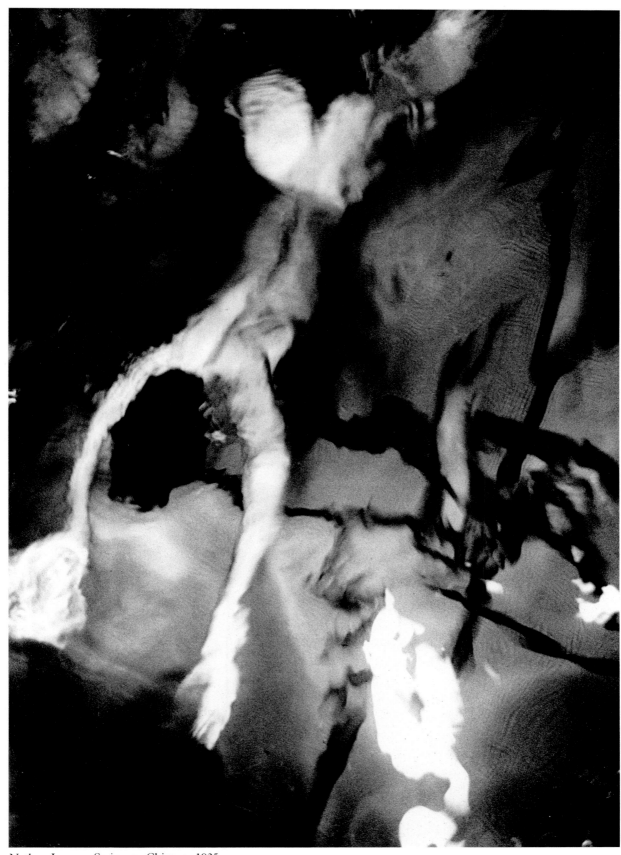

Nathan Lerner, *Swimmer*, Chicago, 1935

PHOTO CREDITS

The photographs in this volume were reproduced with the kind permission of the photographers, with the following exceptions: pgs. 2 and 71 courtesy of the artists and Lieberman and Saul Gallery, New York; pgs. 5 and 49 courtesy Peter C. Jones, New York; pgs. 8, 9, 10, 12, 13, 26, 43, 48, 52 top, and 70 courtesy F.C. Gundlach, Hamburg, West Germany; pgs. 33 and 73 courtesy dpa-Bild/Frankfurt; Photoreporters, New York; pg. 44 courtesy Pace MacGill Gallery, New York; pgs. 46–47 courtesy Laurence Miller Gallery, New York; pgs. 52, 54, 55, 69, 76, 78 and 79 courtesy the photographers and Magnum Photos Inc., New York, Paris and London; pg. 57 courtesy Metro Pictures, New York; pgs. 61 and 67 courtesy the artist and The Witkin Gallery, New York; pg. 62, "from *Swimmers* (Matrix, 1979) a book of 29 images from 1976–1979, during which period I pioneered the technique of the camera lens half in and half out of water in a single straight photograph." (Jerry Gordon); pg. 64 cyanotype and gum bichromate, courtesy Thomson Gallery, Minneapolis; pg. 65 black and white silver print toned (iron and sodium sulfide print toners), dyed, watercolor, pencil and enamel; pg. 68 hand colored dye transfer print. pp. 82, Hippolyte Bayard. Calotype. Essen, Folkwangschule; pp. 82, Henri Le Secq. Calotype. Collection Bibliotheque du Musée des Arts Decoratifs, Paris; pp. 83, Honoré Daumier. Collection Hans Christian Adam; pp. 84, Anonymous. Stereo daguerrotype. Collection Fotomuseen im Stadtmuseen, Munich; pp. 84, Anonymous. Albumen print. Royal Archives, Windsor Castle. By gracious permission of Her Majesty Queen Elizabeth II; pp. 85, Thomas Eakins. Albumen print. Collection The J. Paul Getty Museum, Malibu, California; pp. 85, Underwood & Underwood, Albumen print. Collection of Hans Christian Adam. pp. 86, Louis Boutan, From Michel Braive, *Das Zeitalter der Photographie*, Munich, 1965; pp. 87, F.W. Guerin. Silver gelatin print. Collection HungArt, Budapest; pp. 87, Anonymous. Collection The International Museum of Photography at George Eastman House, Rochester, N.Y.; pp. 88, courtesy of The André Kertesz estate, New York; pp. 89, David Hockney. Color postcard published by Galerie Wilde, Cologne; pp. 90, Yosiru Iwahasi. From Walther Heering, *Das grosse Buch der Rolleiflex*, Hamburg, 1935; pp. 90, Anonymous. International Museum of Photography at George Eastman House, Rochester, New York, IMP/GEH Still Collection; pp. 91, © 1984, courtesy the estate of Garry Winogrand; The Fraenkel Gallery, San Francisco. Silver gelatin print. Collection The International Museum of Photography at George Eastman House, Rochester, New York.

TEXT CREDITS

The excerpts in this volume were reprinted with the kind permission of the following: p. 1, from *The Metamorphoses*, trans. Rolfe Humphries; p. 7, from *Pablo Neruda; Selected Poems*, bilingual edition edited by Nathaniel Tarn. © 1970 by Anthony Kerrigan, W.S. Merwin, Alastair Reid, and Nathaniel Tarn. © 1972 by Dell Publishing, reprinted by arrangement with Delacourt Press/ Seymour Lawrence. p. 14, "Sexual Water," from Pablo Neruda, *Residence on Earth*, © 1958, 1961, 1962 Editorial Losada. © 1973 by Pablo Neruda and Donald D. Walsh, New Directions 1973; p. 24, from "The Meadow Mouse," © 1963 by Beatrice Roethke as Executrix of the Estate of Theodore Roethke. Reprinted by permission of Doubleday and Faber and Faber Ltd.; p. 28 "I am Here," excerpt from a poem by Robert Mezey. Reprinted by permission of the author; p. 32 from "Paean To Place" by Lorine Niedecker, from *The Granite Pail*, ed. Cid Corman, North Point Press 1985, © 1985 by the Estate of Lorine Niedecker, Cid Corman Executor; p. 34 Lou Lipsitz, "Cold Water," in *Cold Water*, Wesleyan University Press, © 1981; p. 39 "The Nude Swim," from *The Complete Poems: Anne Sexton*, copyright © 1981 by Linda Gray Sexton and Loring Conant, Jr., executors of the will of Anne Sexton; p. 42 "The Lifeguard" from *Drowning with Others*, © James Dickey 1961, originally published in *The New Yorker*, Wesleyan University Press 1961; pp. 46–47, "Pleasure Seas" from *Elizabeth Bishop: The Complete Poems 1927–1979*, McGraw Hill-Ryerson, Toronto 1983, © 1983 by Alice Helen Methfessel; p. 50 "The Beach in August," from *The Collected Poems of Weldon Kees*, ed. Donald Justice, University of Nebraska Press, 1975. © 1943, 1947 and 1954 by Weldon Kees. © 1960 by John A. Kees; p. 56 from *Tristes Tropiques* Librarie Plon, Paris, 1955. p. 64, Section 10, from *Laps*, © 1984 by Michael Blumenthal, The University of Massachusetts Press, 1984; p. 70 from *Easy Travel to Other Planets*, Farrar, Straus & Giroux, 1981, © Ted Mooney, 1981; p. 72 "After Dover Beach," *from Collected Poems of Archibald MacLeish, 1917–1952*, © 1952. Reprinted by permission of Houghton Mifflin Co; p. 92 from "The Harbor," in *The Collected Poems of Derek Walcott*, © Derek Walcott, 1980, Collins Publishers.

ACKNOWLEDGMENTS
We are indebted to F.C. Gundlach, whose collection on this subject is unsurpassed and Hans Christian Adam, whose knowledge and expertise throughout has been critical to the project. Mr. Gundlach's exhibition at the PPS Galerie, Hamburg, 1987, "Menschen am Wasser" and H.C. Adam's book "Menschen im Wasser," Berlin: Dirk Nishen Verlag, 1987 were the catalysts for this publication.

Thanks too, to the photographers, whose good will, patience and understanding has made a very difficult project possible—we are so grateful.

We would like to thank also Daniel Simko for his admirable editorial suggestions for the texts included throughout the book; Carolyn Forché and Sally Dixon for their valuable literary recommendations; Agnes Sire and Meredith Hankey of Magnum Paris and Marianne Schieve of Magnum New York, as well as Temple Smith of Esquire, for their indefatigable assistance; and also Julie Saul and Nancy Lieberman of Lieberman and Saul Gallery, Peter Galassi of MOMA, David Goldsmith of Metro Pictures, Jane Bolster of Pace-MacGill, Peter C. Jones, Thomas Mohr of the German Press Agency, dpa/Frankfurt, Roberta Boehm of Photoreporters, Petra Olschewski of Verlag Photographie, Frankfurt, Robert Burges, Terri Barbero of Archive; and, in Japan, both Joel Sackett and Koko Yamagishi, for their very generous assistance.

PHOTOGRAPHERS IN THE EXHIBITION
The work of the following photographers who are represented in the SWIMMERS exhibition was not able to be reproduced in this catalog because of space restrictions. They are listed below alphabetically:

Niki Berg, David Berkwitz, Owen Butler, Michelle Campbell, Henri Cartier-Bresson, Susan Copen-Oken, Pamela De Marris, Jed Fielding, David Graham, David Hockney, Suda House, George Hoyningen-Huene, André Kertész, Julie Mihaly, Arno Raphael Minkkinen, Richard Misrach, Pablo Ortiz Monasterio, Rosalind Kimball Moulton, Nicolas Nixon, Gilles Peress, Jane Regan, Sebastiao Salgado, Volker Schöbel, Chip Simons, Priscilla Smith, Joel Sternfeld, Jock Sturges, Catherine Wagner, Brett Weston.